INDIAN COUNTRY

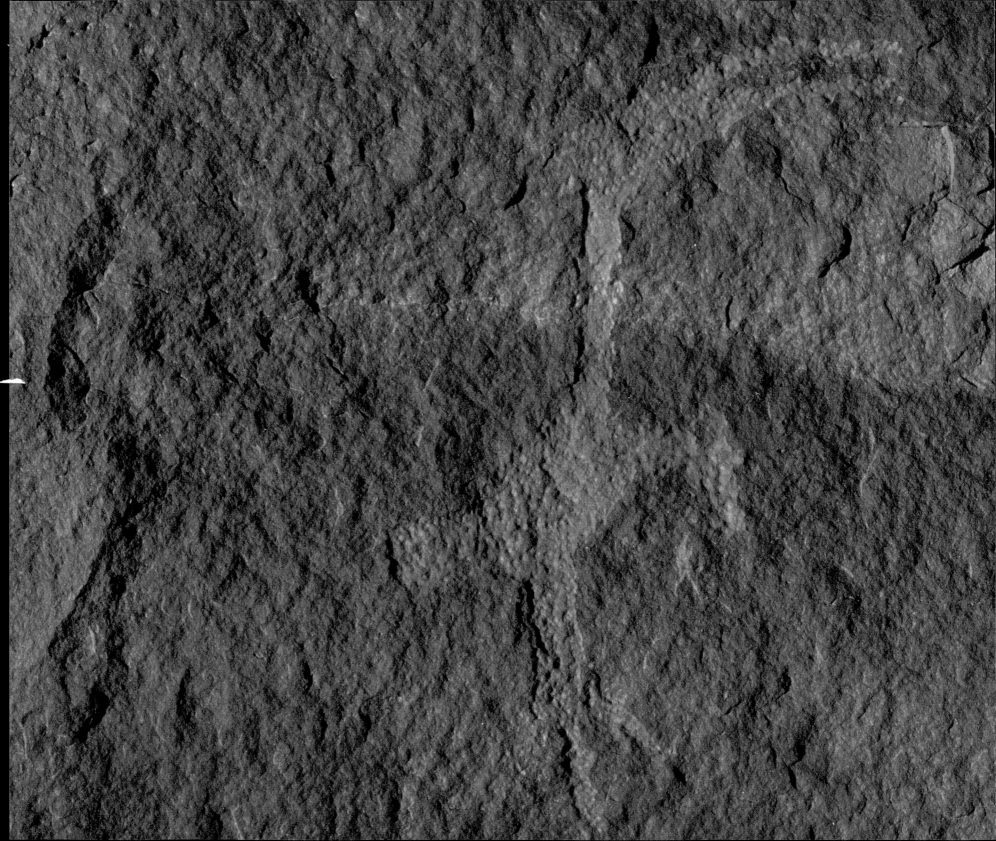

INDIAN
COUNTRY

SACRED GROUND · NATIVE PEOPLES

JOHN ANNERINO

THE COUNTRYMAN PRESS
WOODSTOCK, VERMONT

Library of Congress Cataloging-in-Publication Data
Annerino, John.
 Indian country : sacred ground, native peoples / John Annerino. — 1st ed.
 p. cm.
 Includes bibliographical references.
 ISBN 978-0-88150-716-4 (alk. paper)
 1. Indians of North America—Southwest, New—Antiquities. 2. Indians of Mexico—Antiquities. 3. Sacred space—Southwest, New. 4. Sacred space—Mexico. 5. Southwest, New—Antiquities. 6. Mexico—Antiquities. I. Title.

 E78.S7A648 2007
 972'.01—dc22

 2007016152

Cover and interior design and composition by Eugenie S. Delaney
Cartography by Jacques Chazaud

Published by The Countryman Press, P.O. Box 748, Woodstock, VT 05091
Distributed by W. W. Norton & Company, Inc., 500 Fifth Avenue, New York, NY 10110
Printed in China by R.R. Donnelley

10 9 8 7 6 5 4 3 2 1

PREVIOUS PAGE: *Bird petroglyph, Mystery Valley, Arizona.*

OPPOSITE: *Eddie Two Clouds, Mescalero Apache, Oklahoma.*

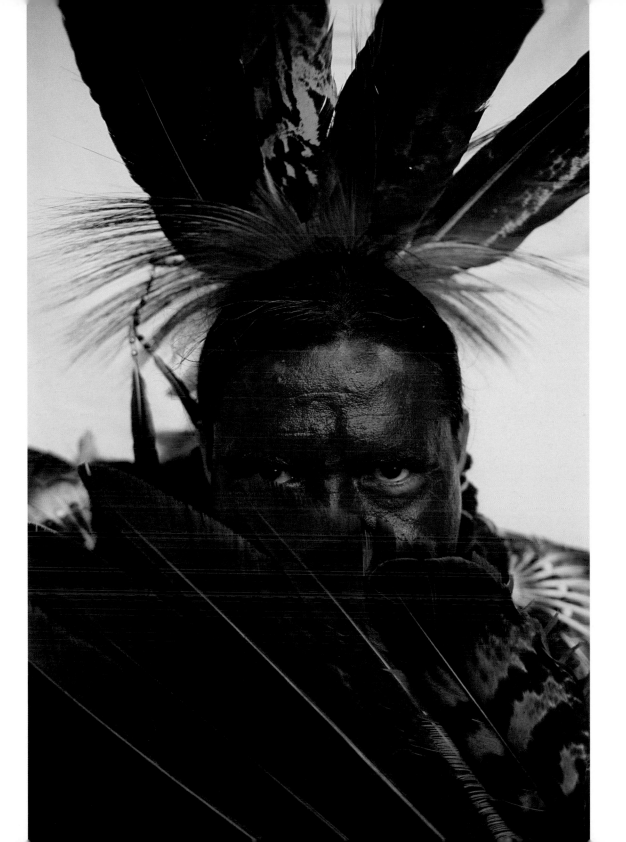

The ground on which we stand
is sacred ground.
It is the dust and blood
of our ancestors.

— CHIEF PLENTY-COUPS,
1909

BOOKS BY JOHN ANNERINO

Photography

DESERT LIGHT
A Photographic Journey through America's Desert Southwest

CANYON COUNTRY
A Photographic Journey

GRAND CANYON WILD
A Photographic Journey

ROUGHSTOCK
The Toughest Events in Rodeo

APACHE
The Sacred Path to Womanhood

PEOPLE OF LEGEND
Native Americans of the Southwest

THE WILD COUNTRY OF MEXICO
La tierra salvaje de México

CANYONS OF THE SOUTHWEST

HIGH RISK PHOTOGRAPHY
The Adventure Behind the Image

Also by the author

RUNNING WILD
An Extraordinary Adventure of the Human Spirit

DEAD IN THEIR TRACKS
Crossing America's Desert Borderlands

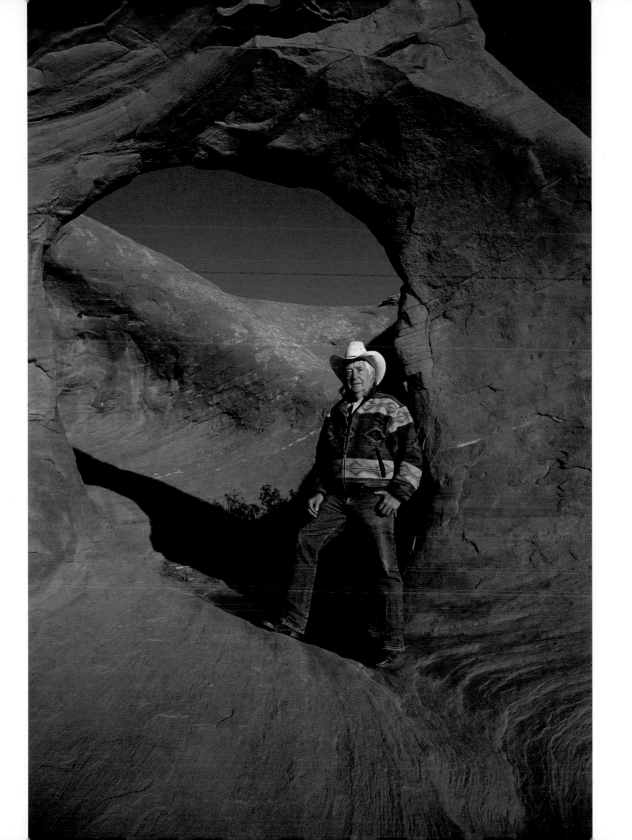

For Bill Crawley, Osage

Cly Arch,
Monument Valley,
Arizona.

ACKNOWLEDGMENTS

OVER THE YEARS, MANY EDITORS SUPPORTED MY WORK THROUGHOUT NATIVE AMERICA and indigenous Mexico, and I thank them: Andrea Villaseñor, Directora, *Centauro,* and Elvira Mendoza, Directora, *Geomundo*, in Mexico City; Marie Schumann and Melvin L. Scott, Picture Editors, *Life;* Gary Avey, Editor, *Native Peoples Magazine*; Guy Cooper, Picture Editor, *Newsweek*; Donnamarie Barnes, Picture Editor, *People*; Lisa Passmore, Photography Editor, *Travel-Holiday*; Jennifer B. Coley, Director, Liaison International Photo Agency in New York; and Anna Luccarina, Picture Editor, Marka Graphic Photo & Archivium in Milan. I'd also like to thank Pete Ensenberger, Director of Photography, *Arizona Highways,* for his support. I have not forgotten Paul Schatt, Editor, *The Arizona Republic*, for assigning me my first magazine feature years ago, "Sacred Mountains of the Navajo," and I'm grateful to Stephanie Robertson, former Editor, *The Arizona Republic* Sunday *Perspective*, for many stories she subsequently assigned me among Arizona's and Mexico's indigenous people.

Access to many areas featured in this book would not have been possible without the sacred knowledge and guidance of those who opened secret doors for me: Among the Apache, medicine men Robertson Preston and Leroy Kenton, spiritual leader Harrison Bonito, the Goseyun family, Wanda Smith, and Eddie Two Clouds; in the Chiricahua Apache Sierra Madre homelands, padre Davíd José Beaumont, OFM Cap., Bertha Alicia Aguilar-Valenzuela, and "El Cuñao"; among the Navajo, Code Talker Eddie Draper and medicine man Raymond Haskie; among the Pápago, John Bilby, elder Verna Morrow, the late Ed Kisto, and Chico Shunie; among the Seri, Rosa Barnett, Jim Hills, Ernesto Molino, and Angelita Torres.

Osage guide Bill Crawley was indispensable in showing me the secret world of Monument Valley. Friend Michael Thomas endured a cold bivouac with me atop the region's most sacred mountain. And my wife, Alejandrina, and young sons, John and Nathan, showed me new ways to interpret ancient petroglyphs that would have remained indecipherable.

I owe special thanks to Donald H. Bayles, Jr., Theresa Ebarb, and Tony Ebarb.

This book would not have been possible without the talents and hard work of Deb Goodman, Charles Wiggins, Jennifer Thompson, Fred Lee, Dale Evva Gelfand, Eugenie S. Delaney, Jacques Chazaud, Kermit Hummel, and Bill Rusin, who turned my vision into a reality. Thank you!

CONTENTS

Kokopeli, Monument Valley, Arizona.
Named for the Hopi Kachina Kókopilau—
the "Humpbacked Flute Player"—Kokopeli
was reportedly chiseled into rock faces from
Canada to South America during the Hopi's
ancient migrations.

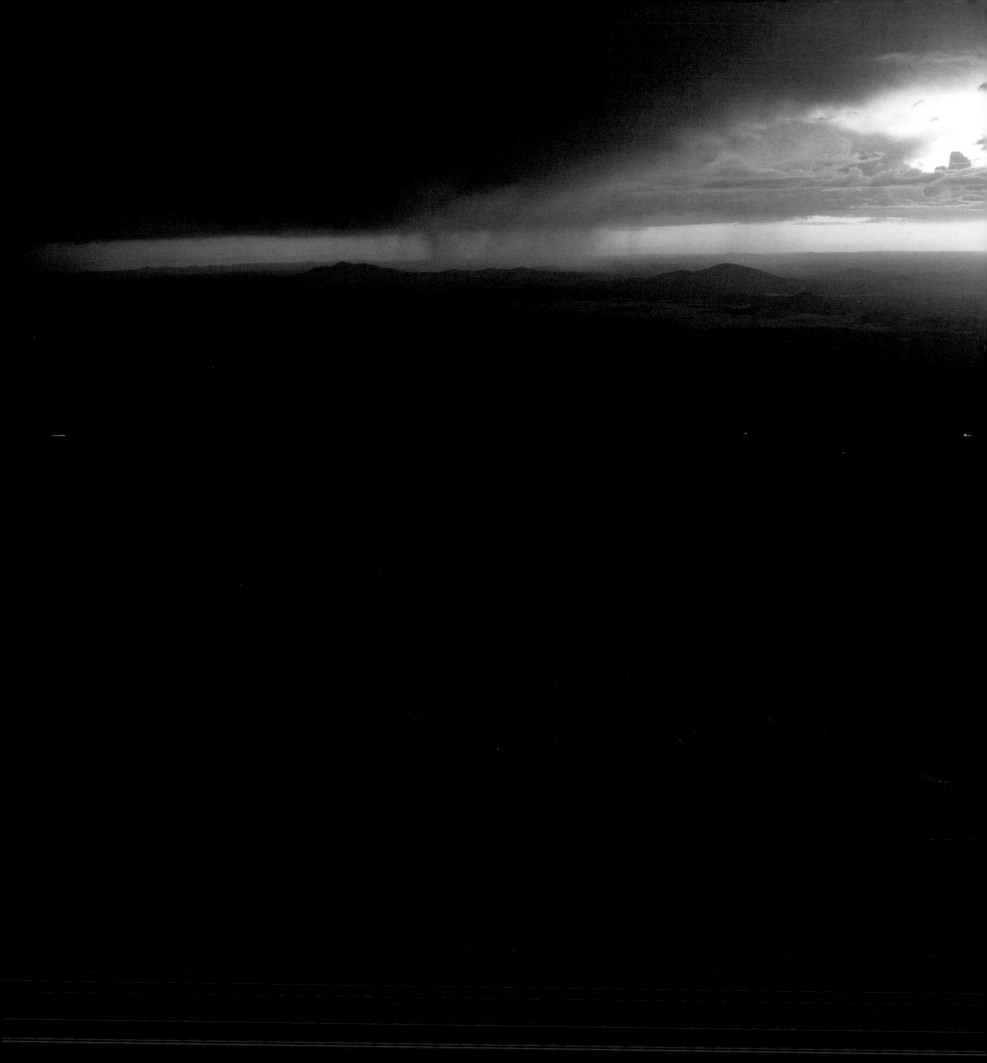

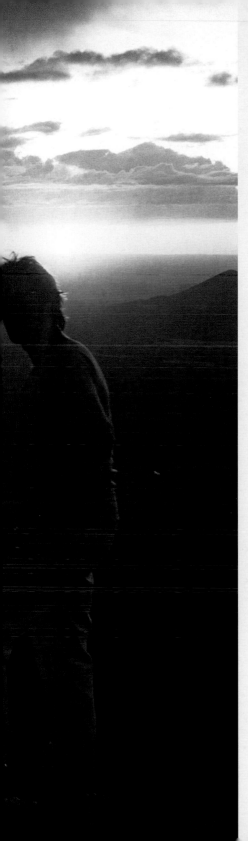

SACRED GROUND, NATIVE PEOPLES

Stand alone on the summit of some sacred mountain and
look far out over the weird rocks and canyons and sage brush flats. . . .
The Navajo knew these to be sacred places just as surely as
they knew the blowing wind and the taste of cold, pure water.

— EDITHA L. WATSON, *Navajo Sacred Places*

VEILS OF PINK CLOUDS DRIFTED OVER THE RED MESAS OF THE COLORADO Plateau as we broke camp above the treeline in an ancient stand of bristlecone pine. The air was cold and sweet. And we gasped with each breath as we climbed over sharp, lichen-covered black stones a thousand feet toward the 12,633-foot summit of Kachina Peaks. By mountaineering standards, Arizona's highest mountain does not compare to the world's loftiest peaks, but for those who believe in such matters, it is the most sacred mountain.

I was not yet a believer.

For years I'd been searching for clues that would unlock the mysteries of such places that have beckoned the Old Ones for thousands of years. Arizona's San Francisco Mountains were said to be the dwelling place of deities. That's where I started looking. I climbed its corniced ridges with ice ax and crampons many times in the dead of winter and hiked its soft paths fall through spring, but I saw no evidence of the Holy People who were said to dwell atop the remains of a fifteen-thousand-foot-high volcano that erupted 1.8 million years ago. On occasion during summer and fall, I ran across verdant meadows and pine forests at its base, along foot trails that wound up through quaking aspen and Douglas fir,

11

until I trod its barren, windswept summit ridges that lead through white clouds crowning the abode of the *katsinas,* "spirit beings" of the Hopi.

Those were my favorite pilgrimages because I was alone in the elements to contemplate the power and beauty of nature. Shivering in running shoes, knee-high wool socks, shorts, a wool sweater, gloves, and hat, I had little time to take in the grand sweep of the 130,000-square-mile Colorado Plateau. On cold, clear days it stretched to the horizon in every direction as far as I could see.

My energy nearly spent just reaching the summit aerie, I had a long run back, floating down off the mountain to my forest camp. Those exhilarating journeys gave me an intimate view of the mountain Native peoples were said to "live with as closely as their own

PREVIOUS PAGE: *Kachina Peaks, Arizona. An enticing vista for climber Michael Thomas, the San Francisco Mountains are home to rainmaking* Kachina *spirits and revered by the Hopi, Navajo, and Havasupai.*

RIGHT: *Sacred Mountain, Arizona. The author holds the snake he encountered atop Kachina Peaks.*

OPPOSITE: *Skeleton Spires, Monument Valley, Arizona. Towering over the ancient realm of the Hopi and Navajo, Skeleton Spires takes its name from mysterious remains discovered in this remote area.*

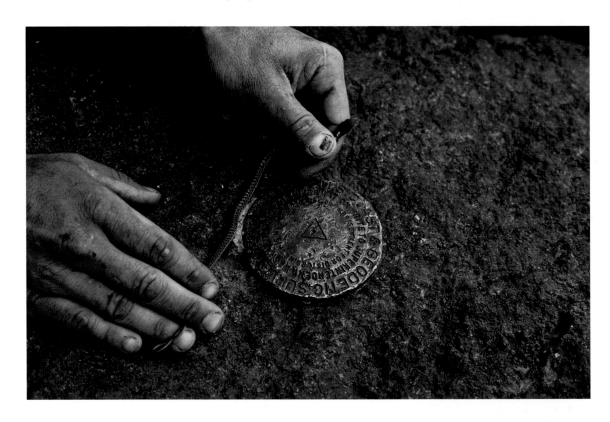

heart-beats." But the spirits Editha L. Watson also described had not yet spoken to me. "It was not astonishing for them [the Navajo] that supernatural beings peopled sacred places and spoke to mortals in the days of old."

Tasting the cold, pure water from Philomena Springs earlier that morning, I was not prepared for the moment that I stepped on the summit of Kachina Peaks, and a small snake slithered across my stony path. I did not know what to make of it. I took off my wool mittens, bent down, and held the delicate creature in my bare hands. Herpetologists, I'd read, considered the uppermost habitat of snakes in North America to be that of the Western rattlesnake, occasionally found at eleven thousand feet above sea level. That was more than fifteen hundred vertical feet below the lugged soles of my mountaineering boots. Why was a cold-blooded serpent gliding through subalpine tundra groundsel? I could not explain it.

Cupped in the palms of my hands, the pencil-thin viper curled around my wind-chapped fingers as I waited a few minutes longer for my young mountaineering students and assistant to join me on the summit. One by one, they lifted their dark snow goggles and glasses and peered down in collective disbelief. I wondered aloud if there was a scientific explanation. It was the only response I could offer. They shrugged and turned their backs to the blowing wind. I put the snake in one of my

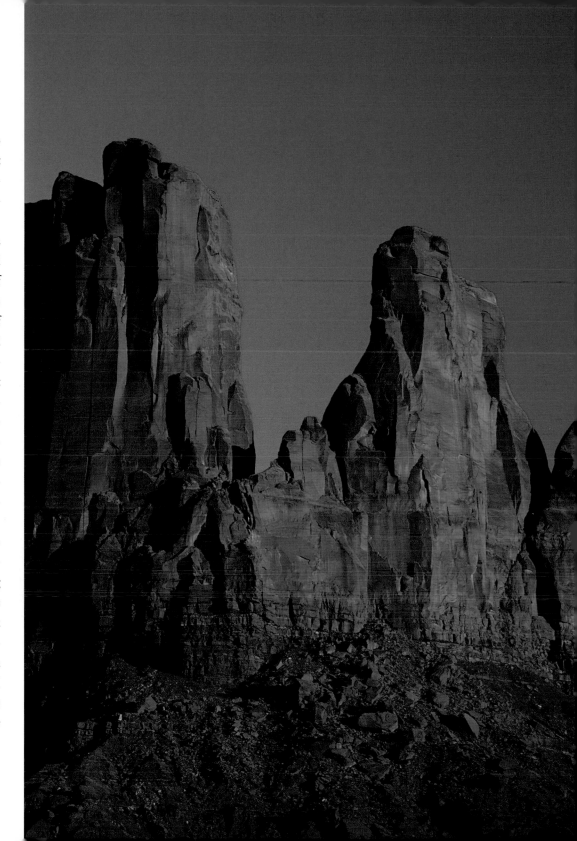

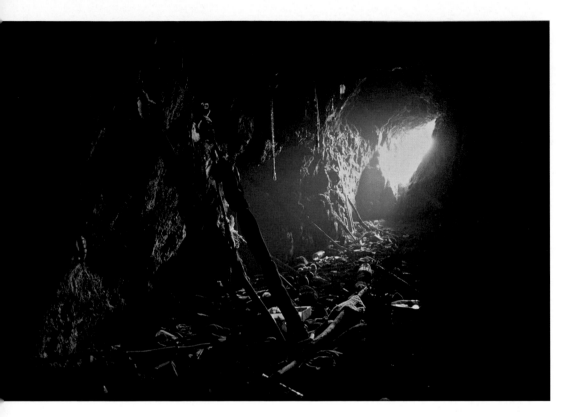

The Sacred Cave, Sonoran Desert, Arizona. Hidden in a vast sweep of Sonoran Desert, Síhuki, *"Elder Brother's House," is the abode of the Ó'odham's creator.*

mittens and tucked it inside my down parka as we packed down the mountain. I needed verification.

A hundred yards down the steep talus, I had a sudden change of heart. If I removed this marvelous creature from the summit, a snake would no longer be there. And who was I to do that? My students huddled behind a colorful windbreak of backpacks as I climbed back up in the thin air to the summit. I placed the snake on the black stones and watched it slither away from where I had found it.

I stood up and felt like I had been hit by a bolt of lightning. Was the snake a sign that had eluded me all these years? I'd been taught that the region's towering monuments, deep canyons, and supernal mountains I'd viewed with awe and mystery were treasured most for the public-lands concept of "sustained yields of wood, water, forage, wildlife, and recreation." Traditional Native peoples viewed the same natural world with profound difference and reverence because it embodied the holy legends, beliefs, and rites of the people, and it defined their spiritual universe.

The experience changed me. And when the trail of the mountain's spirits beckoned me once more, I stood alone on the summit of the sacred mountain, and I looked far out over the weird rocks and canyons and sagebrush flats and began to understand why the region's Native peoples viewed their aboriginal lands as sacred ground.

To Hopi priests who still make pilgrimages to shrines atop the San Francisco Mountains, it was home of the Kachina spirits who brought rain to their parched mesas and cornfields eighty miles east. To the north, I traced the deep serpentine gash of the Little Colorado River Gorge on foot for fifty-seven miles as it wound through imposing, multi-tiered cliffs of the Coconino Plateau. When the Hopi journeyed to the edge of the dark chasm to

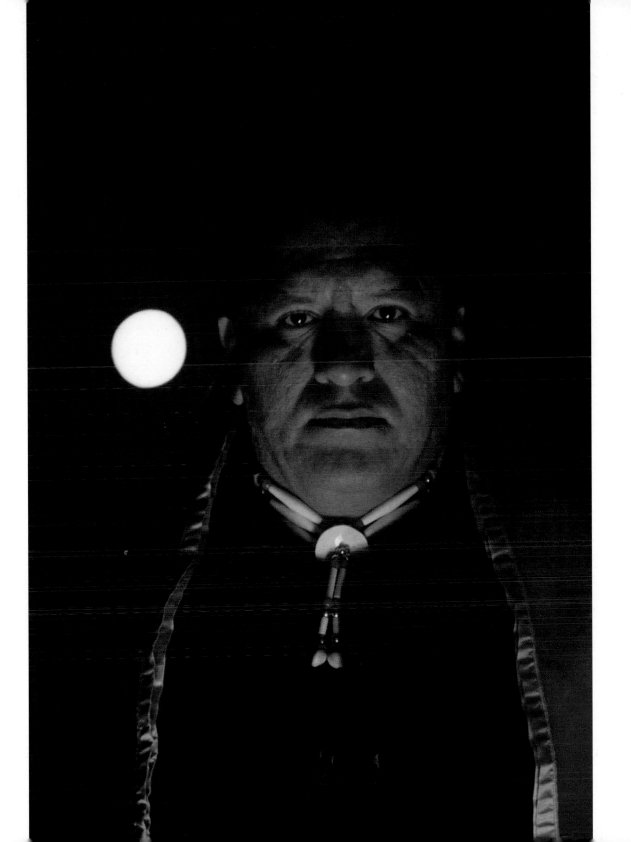

Shaman, Sonoran Desert, Arizona.
Medicine man Melvin Deer prepares to
bless a sacred Hohokam *burial site.*

collect salt in the Grand Canyon, they could see this holy summit they revered as *Navatekiaoui,* "Place of Snow on the Very Top." East to west, I traced the ancient Hopi-Havasupai trade route on foot for a week across the Painted Desert from Oraibi to the Havasupai. When the Havasupai returned to their ancestral canyonlands after trading with the Hopi and Zuni, they, too, could always see this mountain they revered as *Hvehasahpatch,* "Big Rock Mountain." Snowmelt from the mountain fed the sacred springs in the canyon oasis they called home. To the northeast, I crossed the red rock mesas of the Navajo on foot from Sand Springs to the rim of the Grand Canyon. When Manuelito—*Nabááh jilt'áá,* "Warrior Grabbed Enemy"—led a band of western Navajo toward the Canyon to escape the scorched-earth campaign of Colonel Christopher "Kit" Carson in 1863, they, too, could always see this mountain they revered as *Dook'o'oslííd,* "Never Thaws on Top."

There were many such places that the Navajo identified as sacred ground for the Indian Claims Commission on June 29, 1970. They included spires, monuments, canyons, mesas, caves, craters, rivers, and springs, and each was inextricably linked to ceremonies, chantways, oral history, and legends that formed their spiritual geography. It stretched from the foot of *Dook'o'oslííd* to the Four Corners of Arizona, New Mexico, Utah, and Colorado.

This, they knew, as *Dinétah,* "Navajo Land,"

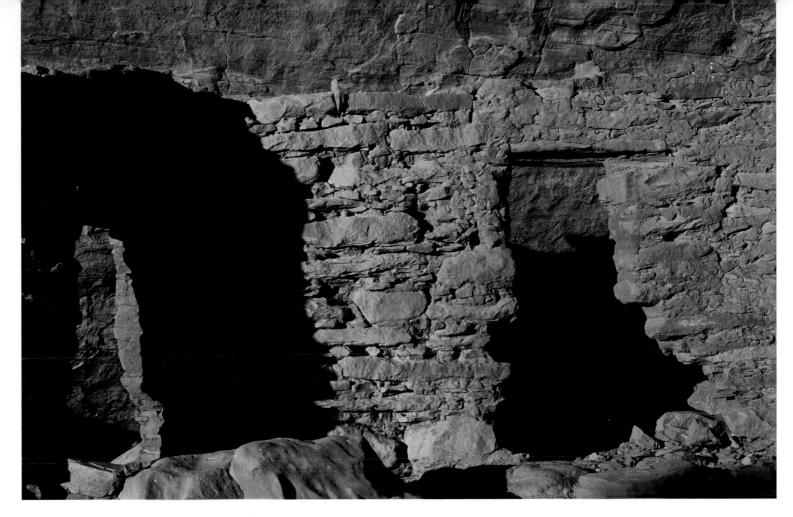

and it was anchored by four sacred mountains that were fastened to the earth by a bolt of lightning, a great flint knife, a rainbow, and a sunbeam. In traditional beliefs, they are: *Sisnaajiní*, "Horizontal Black Belt," 14,317-foot Blanca Peak, the sacred mountain of the East; *Dootł'izhii dziil*, "Turquoise Mountain," 11,389-foot Mount Taylor, the sacred mountain of the South; *Dibé nitsaa*, "Big Mountain Sheep," 13,225-foot Hesperus Peak, the sacred mountain of the North; and the very mountain from which I still viewed their mythical landscape, *Dook'o'osłííd* was the sacred mountain of the West. Medicine men called *ha'athali*, "singers," journeyed to each of these sacred mountains to collect herbs, plants, and soil for their *dzileezh bijish*, "medicine pouches," that they carried as protection and used in healing ceremonies like the Blessingway.

I learned later that wherever I looked in the four cardinal directions, there were many

OPPOSITE: *Council Rocks, Dragoon Mountains, Arizona. The granite megaliths of the Dragoon Mountains offered refuge to the Chiricahua Apache during the 1880s.*

ABOVE: *House of Many Hands, Mystery Valley, Arizona. Mystery Valley was once home to ancestral Puebloans, who inhabited the Four Corners region of Arizona, Utah, New Mexico, and Colorado.*

Apache dí yin *(medicine man) Roberston Preston, Wanda Smith (left) and friend stand for a portrait at the end of a coming-of-age ceremony in Arizona.*

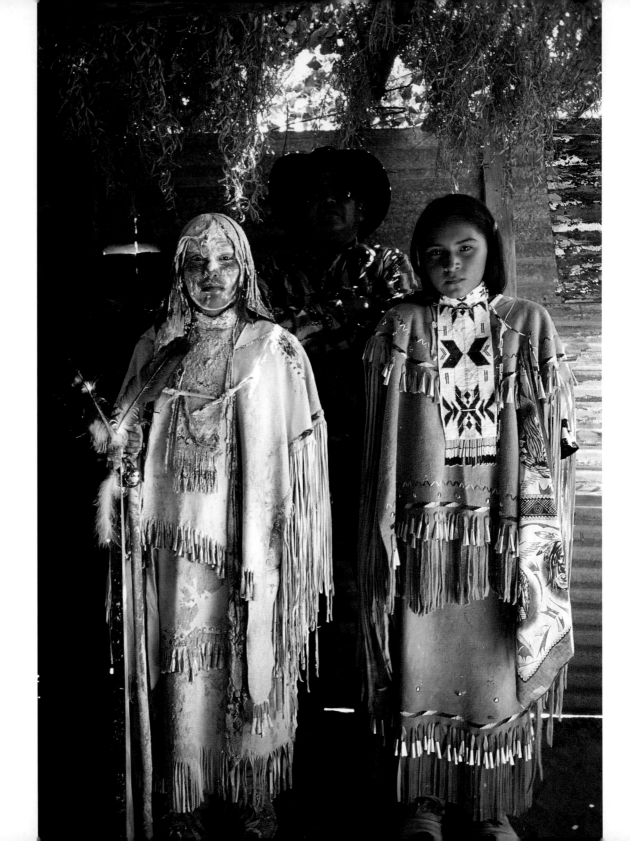

such places lost to modern knowledge that are still revered by Native peoples as sacred ground.

 To the southeast, *Apachería* called to me. In the land of the Apache, I probed the ancient world of the *Mogollon* and climbed the Western Apache's daunting sacred mountain of *Dził Nchaa Sián,* "Big Seated Mountain." I followed the legendary footsteps of Cochise into a hallowed granite stronghold that defied American soldiers at every turn. I witnessed benevolent Mountain Spirits bless the Apache with prayer. And I explored the rugged sanctuary of Geronimo and the Chiricahua Apache deep in Mexico's Sierra Madre, among other journeys, until I came to understand why the Apache still consider their ancestral mountains and plains sacred ground.

 To the northeast, *Dinétah* and *Tusqua* beckoned me. In the land of the Navajo and

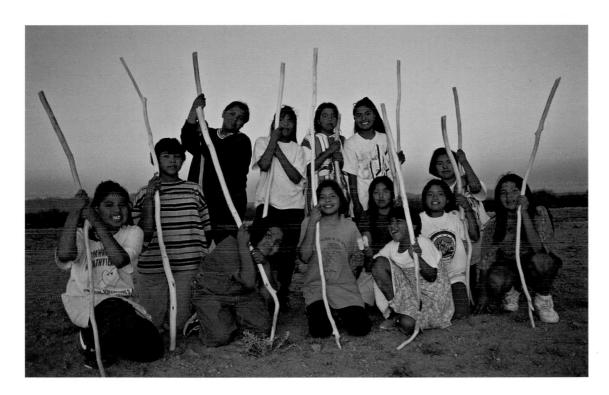

Stickball players, San Simon, Arizona. Elder Verna Morrow revived the ancient game of tóka to instill her students with Tohono Ó'odham traditions.

*Honeymoon House, Mystery Valley,
Arizona. Ancestral Puebloans once stored
clay pots of corn, juniper berries, and
seeds in small granaries throughout the
Colorado Plateau.*

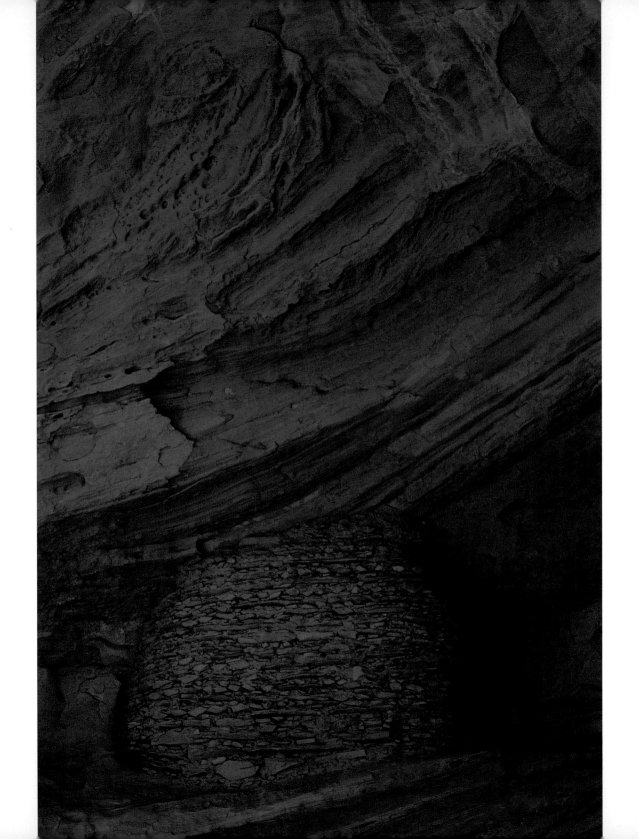

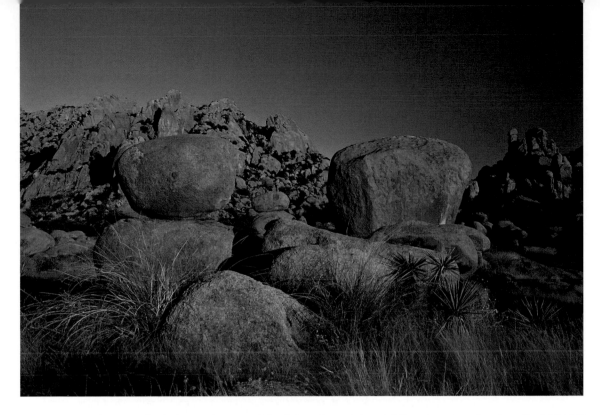

Chiricahua Apache stronghold, Dragoon Mountains, Arizona. Few American soldiers successfully penetrated the Chiricahua Apache's stony domain during the 1880s.

Hopi, I probed the ancient world of the *Anaasází* and *Hisat.sinom* in what is called *Tsé bii' Ndzisgaii,* "Clearings Among the Rocks." I explored the cloud-piercing pinnacles of Skeleton Spires that tower over a secret world few have seen. And I studied the sacred names and paintings on the walls and stones until I came to understand why the Navajo and Hopi still consider their ancestral canyons and mesas sacred ground.

To the south and southwest, *Papaguería* lured me—and it still hasn't let me go. Urged by a Pápago elder, I journeyed to the sacred cave of *Síhuki,* "Elder Brother's House." I watched young students who'd revived the ancient stickball game of *tóka.* I traced my fingertips across hieroglyphic-covered stones. And I witnessed shamans blessing an ancient burial site of the *Hohokam,* "Those Who Are Gone," until I understood why the Pápago, Pima, and Seri still consider their ancestral deserts and seashores sacred ground.

Many years have passed since the mountain spirits touched my hands with the delicate life of a small snake, and many journeys still beckon. But this is the world I came to know as Indian Country: hallowed ground that, against all odds, still resonates with the mythical spirits of the people and the place.

It is sacred ground that Native peoples still seek to preserve.

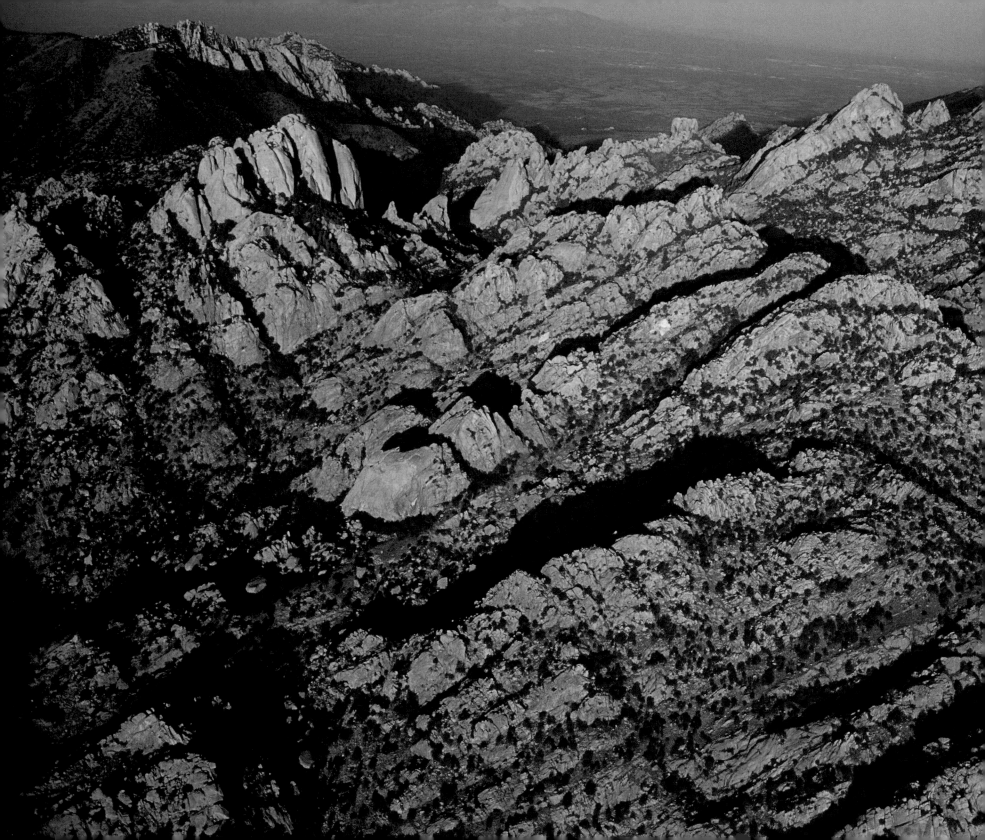

APACHERÍA

In the Land of the Ndé, *Apache*

MOUNTAINS AND PLAINS

———————

Cochise's survival skills were legendary.
For twelve years he successfully eluded troops and
volunteers from four states and two countries.
His allies were his ancestral mountains and
the territorial boundary line, which he used adroitly.
—EDWIN R. SWEENEY, *Cochise, Chiricahua Apache Chief*

THE SHRIEKS OF A RED-TAILED HAWK ECHO OFF THE GRANITE WALLS, AND I look up to watch the raptor glide through powder-blue skies. On this balmy spring day, the air is clean and the sun is bright, as I thread a maze of white granite. I climb higher, and my footsteps grind through gravel and sand as I probe the lofty ramparts of sacred stones. They are everywhere: pebbles that feel like marbles underfoot, boulders that once rolled down on enemy soldiers, slabs that camouflaged carbine-toting "renegades," megaliths that danced by the light of the full moon, pinnacles and ledges that remain the haunt of pumas and golden eagles, and polished cliffs and domes that soar hundreds of feet above shin daggers and serrated beargrass that also guard the narrow mountain trail. It winds beneath a thorny green canopy of mesquite and alligator-barked oak trees as it continues climbing past Half Moon Tank through a granite lair of defiles, box canyons, and crevices, to a breathtaking divide.

23

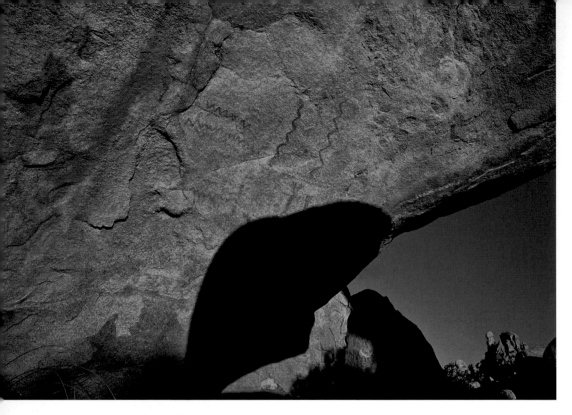

ABOVE: *Traces of the* Mogollon, *Dragoon Mountains, Arizona. Long before it became the dominion of the Chiricahua Apache, the rugged fastness of the Dragoon Mountains was home to the ancient* Mogollon.

PREVIOUS PAGE: *Cochise Stronghold, Dragoon Mountains, Arizona. From their impregnable lair in the 7,500-foot Dragoon Mountains, Cochise and his Chokonen band of Chiricahua Apache warriors had a commanding vantage of enemy soldiers.*

Tales of Cochise demanded that I follow this rocky trail across the hallowed mountain of the Chiricahua Apache. It dates back thousands of years to people called the *Mogollon,* ghosts of the mountains and plains. It carried the yucca-fiber sandal tracks of those mysterious hunter-gatherers, who seemed to vanish from the face of the earth a millennium ago. Crisscrossed by the quiet footfalls of black bears, mountain lions, and whitetail deer, over the next five hundred years the elusive Indian path was worn down by the knee-high lightning-streaked moccasins of the Chiricahua Apache and much later by two hundred stealthy warriors who shadowed their leader into the impregnable stronghold. Only more recently did the trail bear the scuff marks of modern pilgrims trying to follow the spirit tracks of the mythical Apache chief.

I stop and take in the commanding view as bumblebees nurture the colorful mountain flowers. On one side of the divide, I can see the golden sweep of Chihuahuan desert grasslands and silver playas of the Sulphur Springs Valley. It stretches from the dark barranca of Aravaipa Canyon south into Mexico and forms an ancient travel corridor rimmed by the Piñaleno, Dos Cabezas, and Chiricahua Mountains on the east and the Galiuro, Winchester, and Dragoon Mountains on the west. Across the divide, I follow the course of the San Pedro River north from the Mexican border as it purls through lush groves of cottonwood and sycamore trees beneath the forested heights of the Huachuca, Rincón, and Santa Catalina Mountains until it disappears in the embrace of the Gila River. Each of these islands in the sky tower over desert seas, and each was the domain of the Apache, who had a commanding vantage of the enemy troops who'd come to claim their land, their scalps, and their culture. By taking the high ground of southeastern Arizona, the boot heel of New Mexico, and the sierras of northern Mexico, the Chiricahua lorded over the mountains and plains until the relentless tide of Manifest Destiny vanquished them.

Standing atop Cochise's divide with an eagle-eye view of the Chiricahua heartland, I could not foresee that this mythic trail would lead me in many directions throughout *Apachería* over the next decade. It would lead me through Araivapa Canyon—a lush oasis in the cruel haunts of the Sonoran Desert, it had been the refuge of the peaceful *Tséé Zhinnéé,* "People of the Dark Rocks" (Aravaipa Apache), until April 30, 1871, when 150 American, Mexican, and Pápago vigilantes massacred 108 old men, women, and children. It would lead me north to a lone, windy bivouac below the sacred summit of the 10,720-foot Piñaleno Moun-

Balanced Rock, West Stronghold, Dragoon Mountains. The West Stronghold offered Cochise ideal cover to build his gową, *"wickiup," during the summer of 1872.*

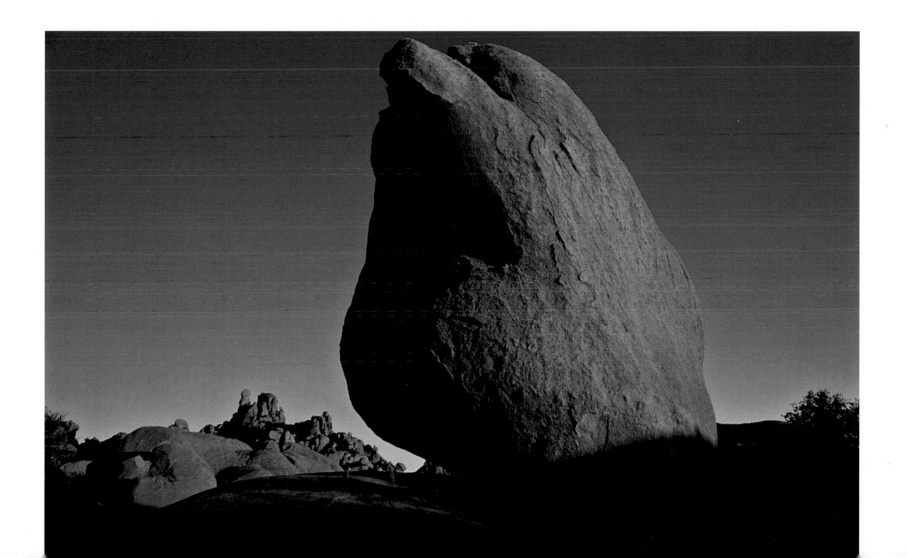

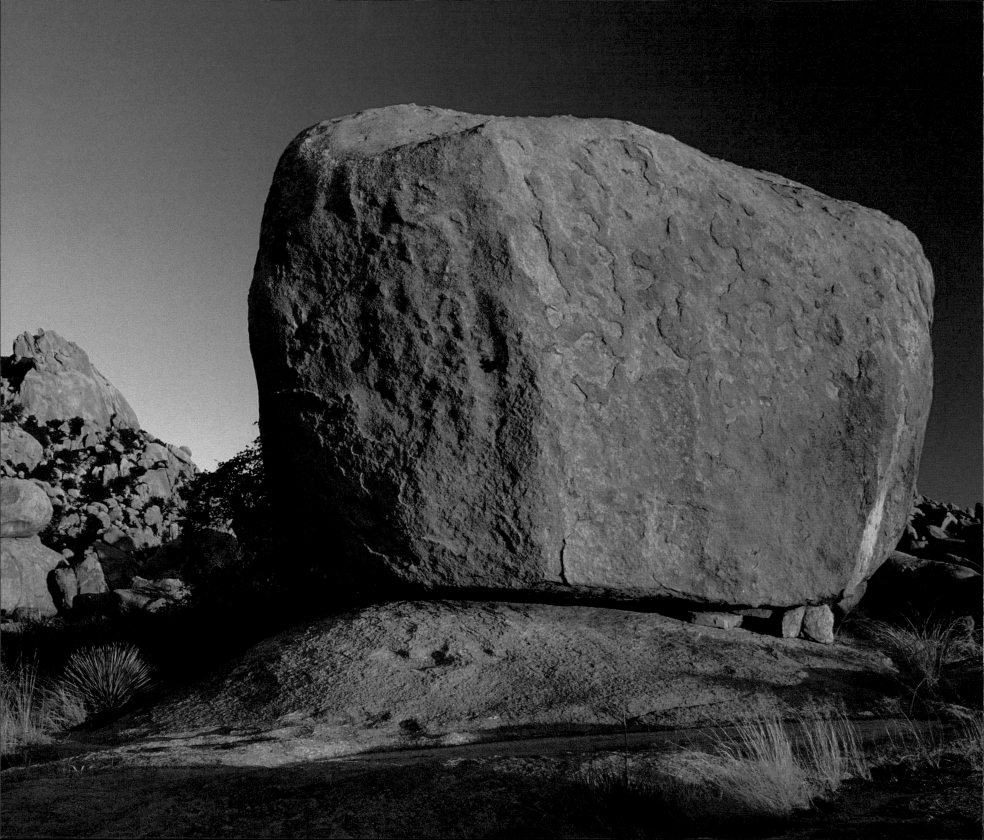

tains, called *Dził Nchaa Siáń,* "Big Seated Mountain," in their Native tongue—home of benevolent Mountain Spirits called *Ga'an,* who danced by ceremonial firelight to carry the prayers of the Apache. It would lead me south to mysterious caves deep in the lost barrancas of Mexico's Sierra Madre—the last sanctuary for Geronimo and thirty-eight Chiricahua who eluded 5,000 American troops until hunger and fatigue forced them to surrender their arms on September 3, 1886. And finally it would lead me east across the Great Plains to Fort Sill, Oklahoma, where I wept at the foot of Geronimo's tomb—a modern Native American shrine, flanked by the headstones of his wife, Zi-yeh, and daughter Eva, the legendary warrior died a prisoner of war on February 17, 1909 far from the homelands he longed for.

I plunge over the edge of the divide and follow the trail of Cochise beneath towering pinnacles that loom over the West Stronghold where the final chapters of his extraordinary life unfolded. My thoughts are plagued by terrible events that ignited the "Apache wars." With a nod from Mexican governor José María Irigoyen, American scalp hunter James "Santiago" Kirker, forty-four men, and the townspeople of Galeana, Chihuahua, bludgeoned and scalped 130 Chiricahua Apache during their sleep the morning of July 7, 1846. There was no turning back for the Chiricahua when they avenged the deaths of their slain brethren. There was no turning back for Geronimo when he avenged the deaths of his mother, wife, and three children massacred and scalped by Mexican troops in Janos, Chihuahua, during the summer of 1850. And there was no turning back for Cochise when he avenged the deaths of his brother, wife, two children, and two nephews who were executed by American soldiers a day's ride east of the Stronghold.

Unjustly accused of kidnapping a twelve-year-old boy named Felix, Cochise was held hostage by Lieutenant George N. Bascom at Apache Pass on February 4, 1872. But the "Wild Fox," as his adversaries were said to have called him, drew his knife, cut the tent that held him captive, and escaped through a wall of soldiers under a hail of gunfire. Seriously wounded by three bullets, Cochise would seek revenge for the murders of his family, who were hanged from an oak tree in Apache Pass by Lieutenant Bascom and his men. What ensued was a decade-long guerilla war against American troops and Mexican soldiers, until Cochise's friend, Indian agent Thomas Jeffords, helped broker peace.

OPPOSITE: *End of the trail, West Stronghold. Two years after making peace with the U.S. government, the aging Cochise was buried with his horse in a secret tomb in the Dragoon Mountains.*

Mesquite tree, West Stronghold, Arizona.

It is late afternoon when the trail winds through the West Stronghold. My companions roll out their bedrolls in a clearing among a cauldron of orange stones, and I strike a small fire as the smoldering red sun sets behind the blue ridge of Apache Peak in the distant Whetstone Mountains. A white moon rises over the granite fangs of the Cochise Divide, and granite totems begin to dance in the firelight around our camp. It's easy to imagine the smoke signals of Chiricahua scouts Chie and Ponce guiding the horseback silhouettes of Jeffords, General Oliver O. Howard, and Lieutenant Joseph A. Sladen into the lair of Cochise.

The journey across the "rugged heights and deep gulches" of the Dragoon Mountains was a trying undertaking for the Bible-quoting Howard, as was his powwow with Cochise when the six-foot-tall chief emerged from his hideaway the next day. At issue was the reservation in Cañada Alamosa, New Mexico, that General Howard had offered the Chiricahua. Cochise held out until Howard acquiesced to establish a reservation that included the Dragoon Mountains stronghold. To make certain Howard wasn't speaking with a "forked tongue," Cochise insisted he ride back across the Dragoons "to Fort Bowie to notify all troops that a cease fire was in effect." The one-armed general acquiesced once more and crossed and recrossed the rugged divide in the middle of the night. On October 13, 1872, peace was made at Council Rocks.

Geronimo continued his lightning hit-and-run skirmishes against Mexican troops and

American soldiers with deadly proficiency, but Cochise found peace amid the spilled blood, broken arrows, and thundering hooves. Two years later the aging chief reached the end of the trail and died in the Stronghold on June 8, 1874.

Peering into the flames of our campfire, I read the words of his friend, Thomas Jeffords, as shadows flicker across the yellow pages. "Upon the death of Cochise," wrote Jeffords, "I found his whole band had stripped themselves of almost their entire clothing and burnt it at his grave . . . a custom among these Indians."

By the burning embers of our fire, the words of Cochise's burial brand me that this is sacred ground for the Apache: "He was dressed in his best war garments," wrote author Frank C. Lockwood, "decorated with war paint and head feathers, and wrapped in a splendid heavy, red, woolen blanket. . . . He was then placed on his favorite horse . . . [and] guided to a rough and lonely place among the rocks and chasms in the stronghold. . . . The horse was killed and dropped into the depths; also, Cochise's favorite dog. His gun and other arms were then thrown in; and, last, Cochise was lowered with lariats into the rocky sepulcher."

The autumn day that I visit Council Rocks with my wife and sons, the wind is whistling through the balanced rocks, beargrass, and oak trees of the West Stronghold. More than a century of dust has collected in deep bedrock mortars that once ground mesquite beans beneath a granite mural of ancient *Mogollon* paintings. The remains of Cochise lie buried somewhere nearby.

I have never gone looking for his secret tomb. I have no desire to. Cochise never surrendered. And his spirit still dwells among these sacred stones.

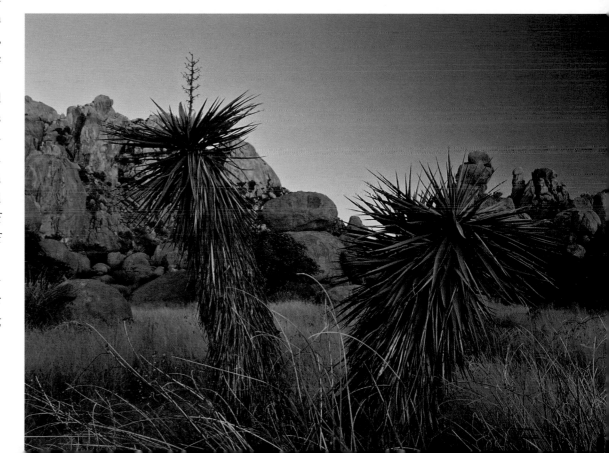

Soaptree yucca, Dragoon Mountains. Otherworldly in appearance, the soaptree was utilized by the Mogollon *and* Chiricahua Apache *for cordage, soap, and baskets.*

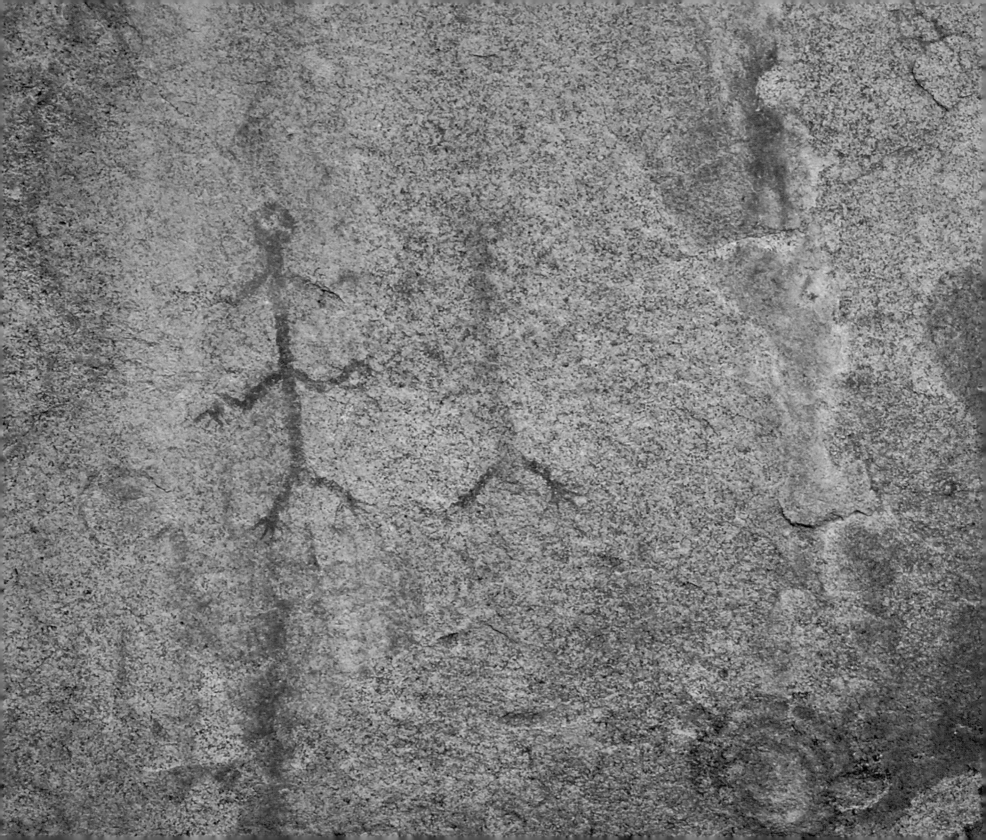

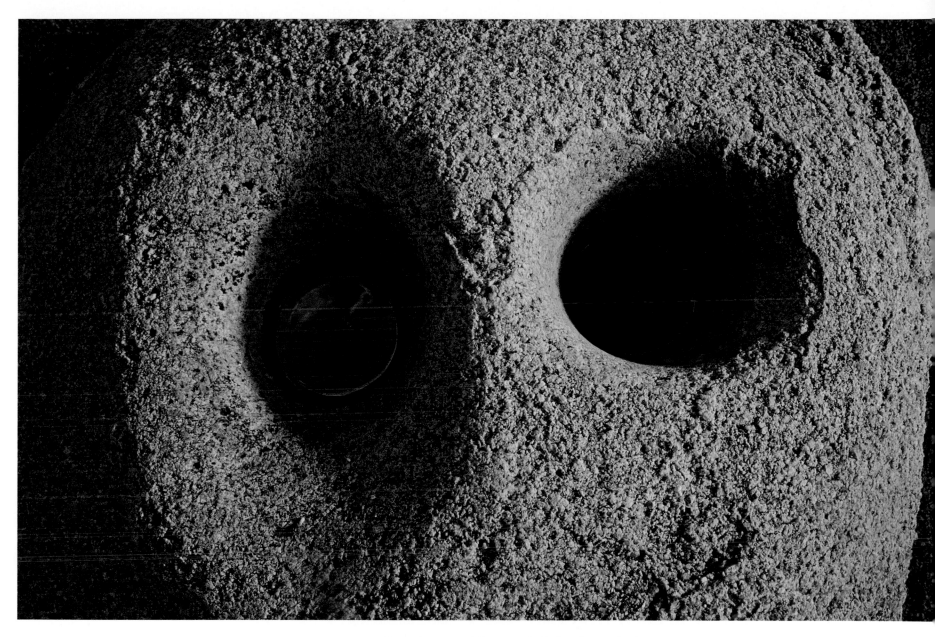

OPPOSITE: *Painted on stone, West Stronghold. For thousands of years the* Mogollon *used natural dyes and yucca-fiber brushes to paint their dreams and journeys on this mystifying canvas.*

ABOVE: *Mesquite beans ground in bedrock mortars provided the* Mogollon *and Chiricahua Apache flour for making* atole, *a nutritional gruel, and for mesquite cakes, which were roasted over hot stones.*

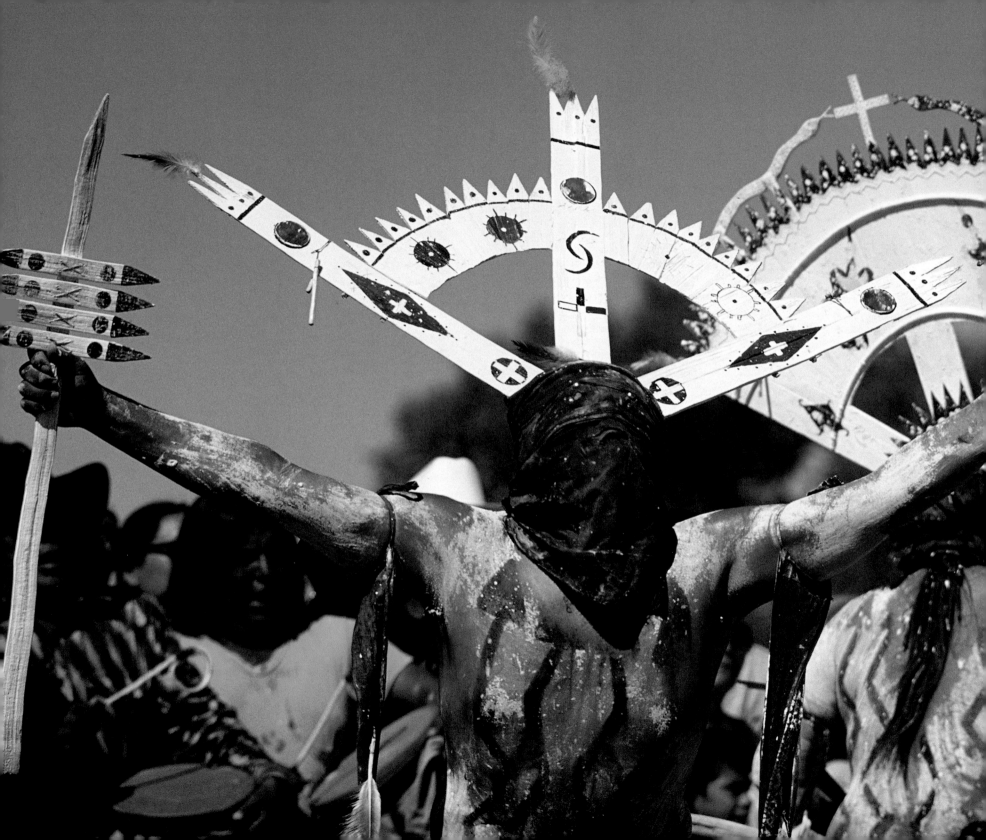

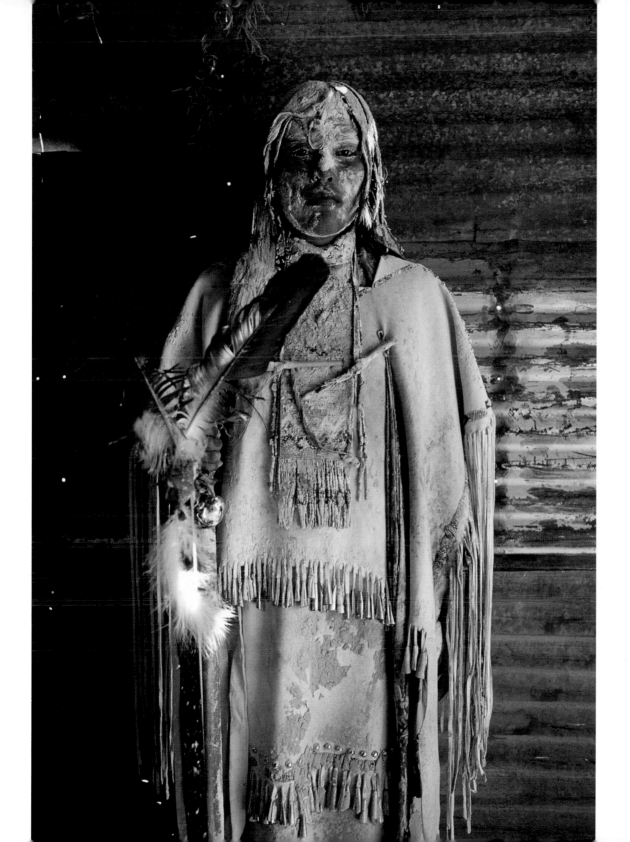

OPPOSITE: Ga'an, *"Mountain Spirits,"*
Arizona. A benevolent Mountain Spirit
blesses the ceremonial ground of the
San Carlos Apache during a four day
and night coming-of-age ceremony called
na ih es, *"getting her ready," for Wanda*
Smith (LEFT) *who embodies the spirit of*
Ih Sta Nedleheh, *"White Shell*
Woman," Mother of the Apache.

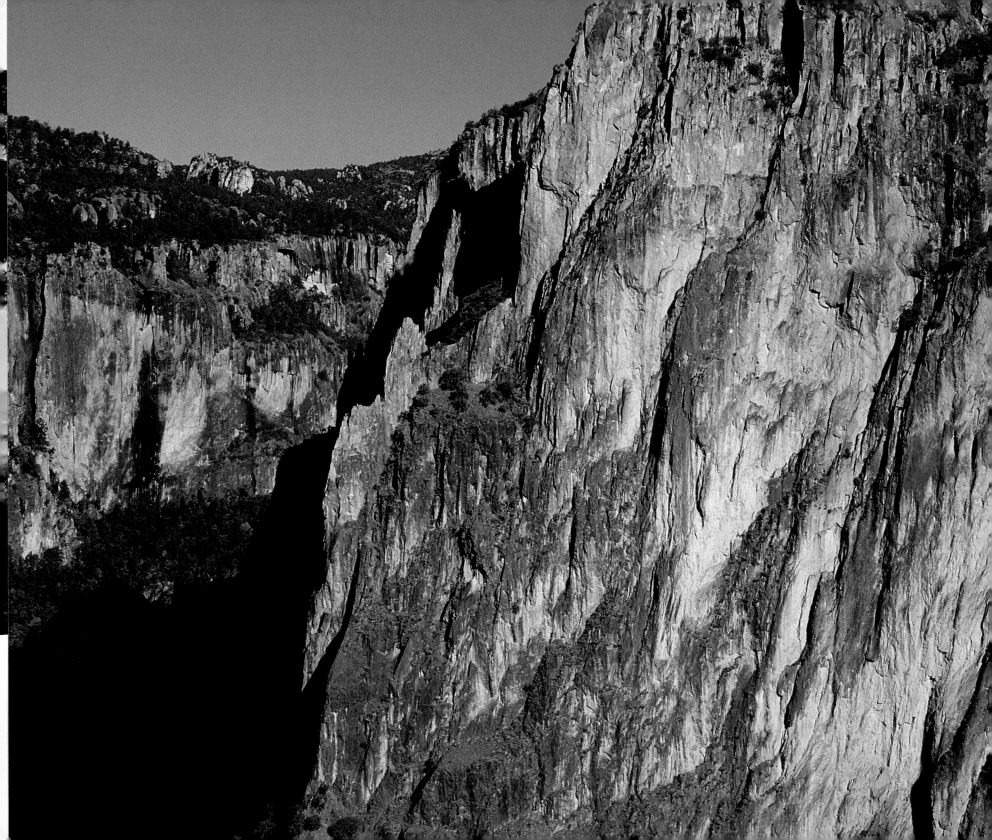

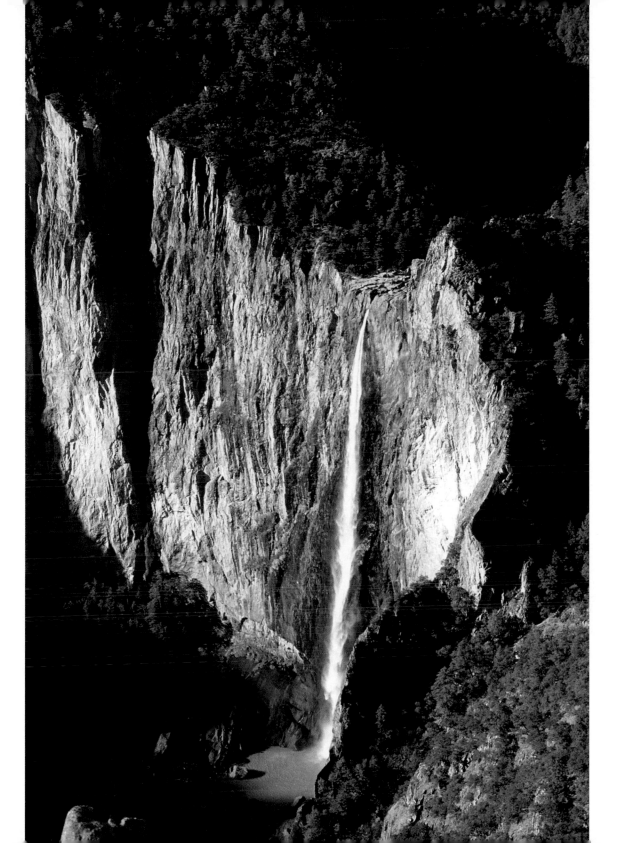

OPPOSITE: *Candemeña Canyon, Sierra Madre, Mexico.*

LEFT: *867-foot Basaseachi Falls marked the southern limits of the fleet-footed Chiricahua Apache, who found sanctuary deep in Mexico's rugged Sierra Madre Occidental during the U. S. government's war against the Apache.*

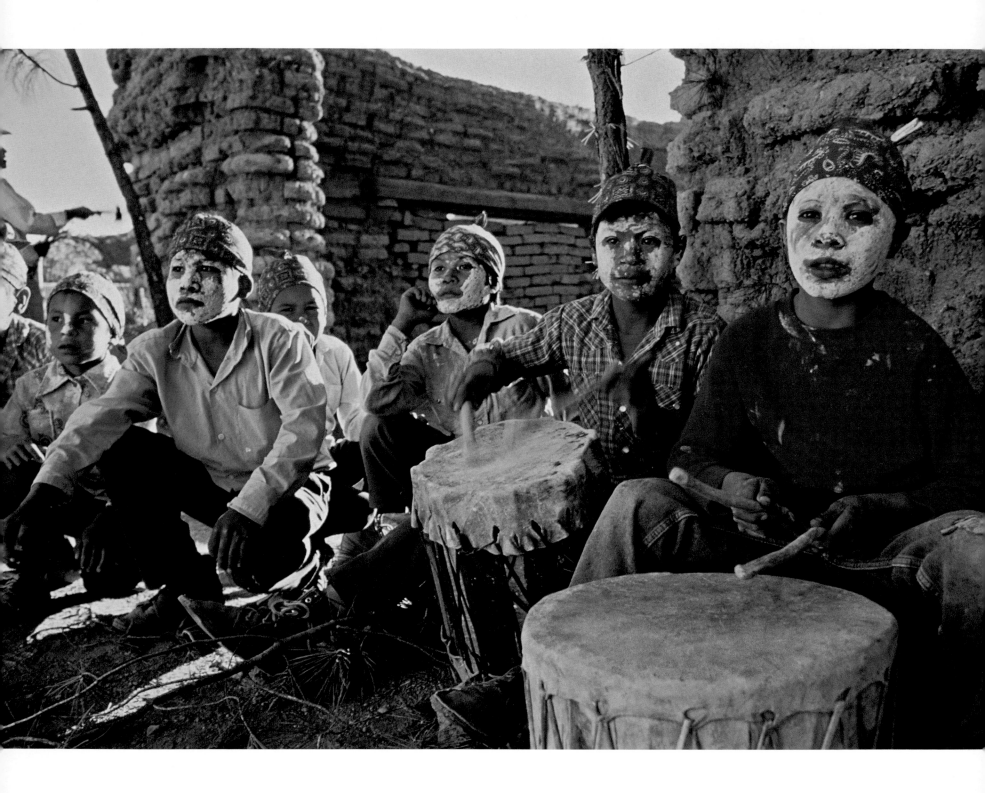

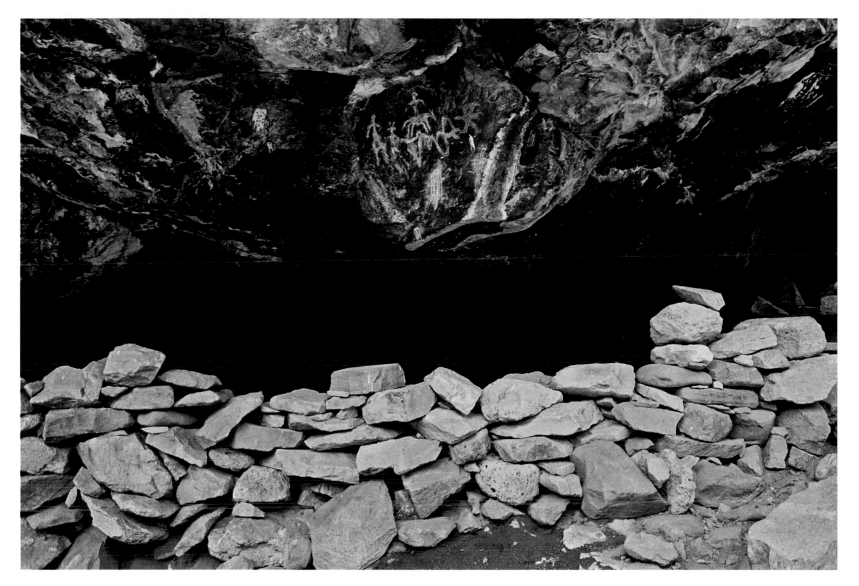

Mountain Pima drummers, Sierra Madre, Mexico. Faces painted with sacred white clay, Ó'ob drummers beat rhythms to their Semana Santa *ceremonies every Easter.*

Cave dwelling, Sierra Madre, Mexico. Cave-dwelling ancestors of the O'ob fought incursions into their mountain retreat by Chiricahua Apaches who were on the run during the 1880s.

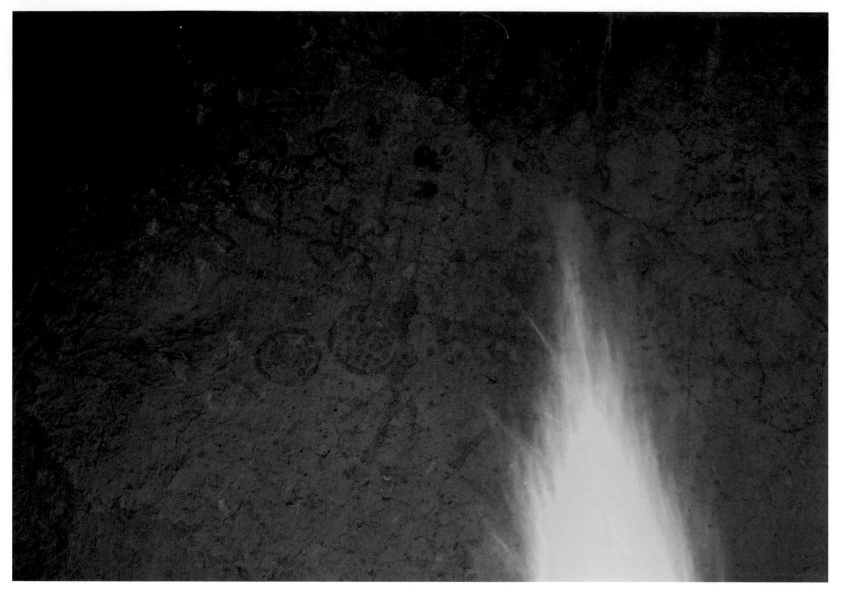

*Chiricahua Cave, Sierra Madre. Lost in the mythical barrancas of the Sierra Madre, long-forgotten
pictographs of a warrior, shaman, and Mountain Spirit mark the historic passage of the Chiricahua
Apache and still reflect spiritual beliefs* (RIGHT) *practiced by Mountain Spirits, who bless the sacred
grounds and carry the prayers of the Apache in the* Bi til tih, *"Night Before Dance," in Arizona.*

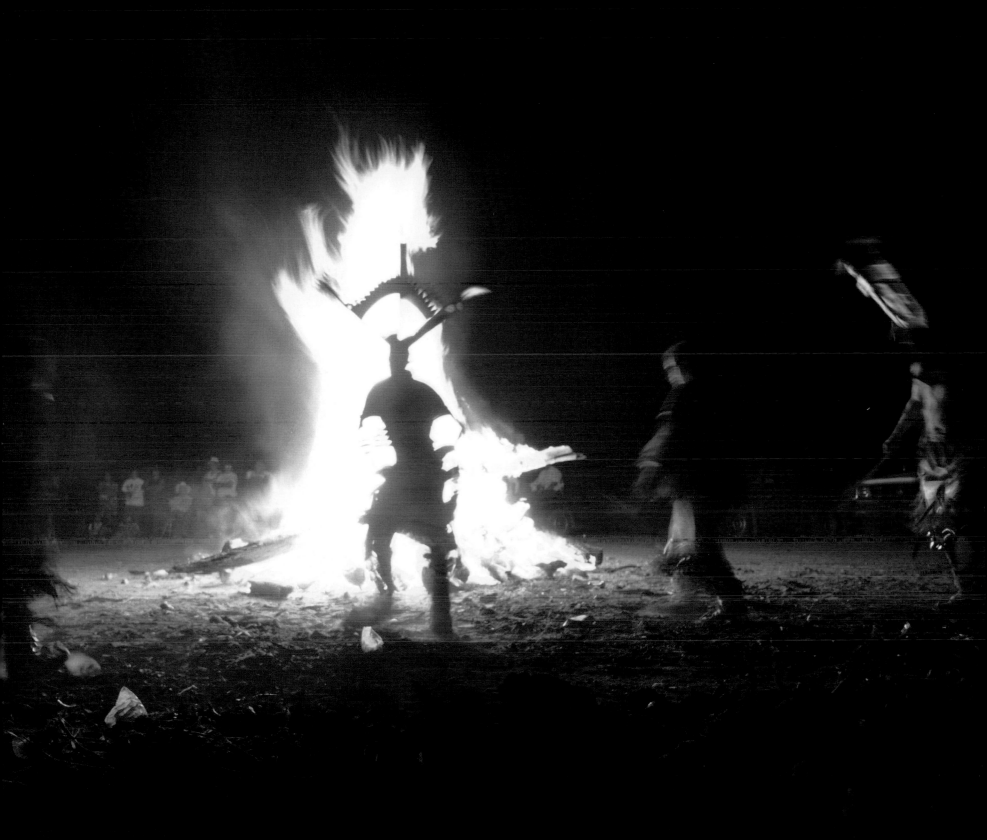

One-horned Buffalo Dancer, New Mexico. The San Juan Tewa celebrate sacred journeys that they once made across Jicarilla and Kiowa Apache lands to hunt kaněnă, "buffalo," on the Great Plains.

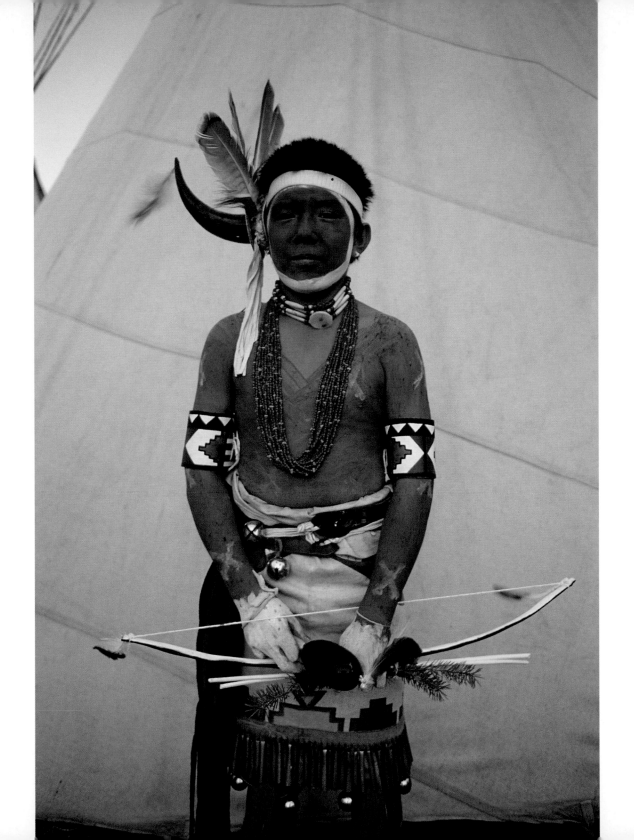

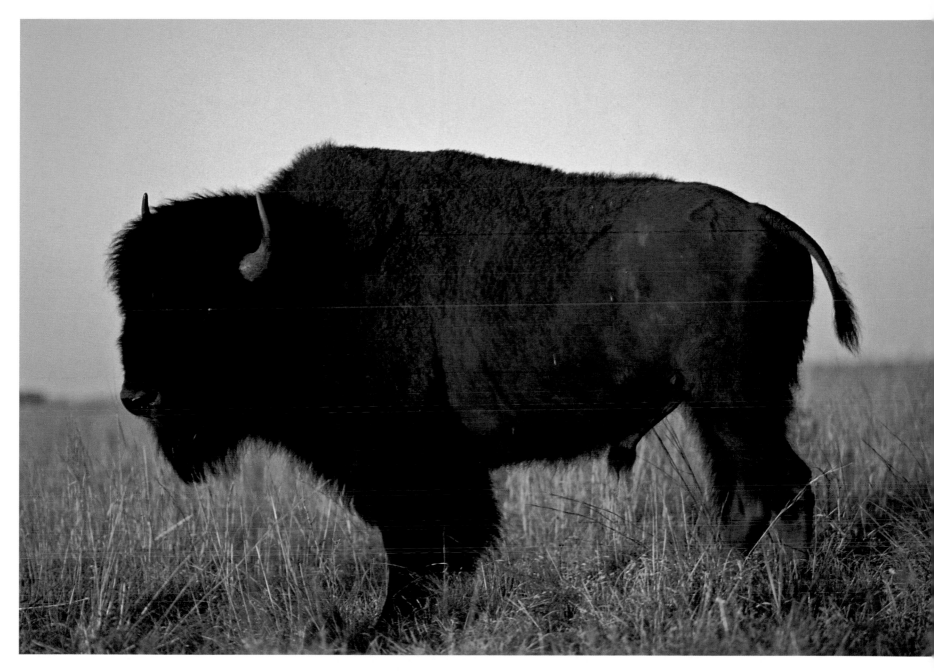

Buffalo, Great Plains, Oklahoma. During their reign, the Apache controlled 90,000 square miles of ancestral lands that stretched from the plains of Oklahoma to the mountains, deserts, and canyons of West Texas, New Mexico, and Arizona and the Sierra Madre of northern Mexico.

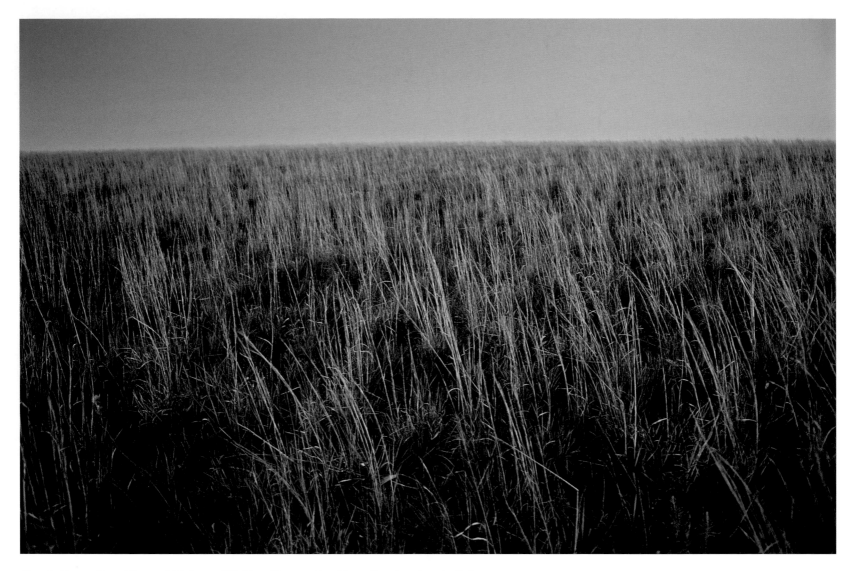

Sea of Grass, Great Plains, Oklahoma. Wielding Sharps .50-caliber rifles, American buffalo runners, French voyageurs, *and Mexican* ciboleros *turned the Great Plains into an empty sea of grass by 1900 after decimating once-great buffalo herds to just 541 animals.*

OPPOSITE: *Buffalo herd, Great Plains, Oklahoma. At their peak in 1850, some 60 million buffalo ranged across 220,000 square miles of tall grass prairies that stretched from Canada to Mexico.*

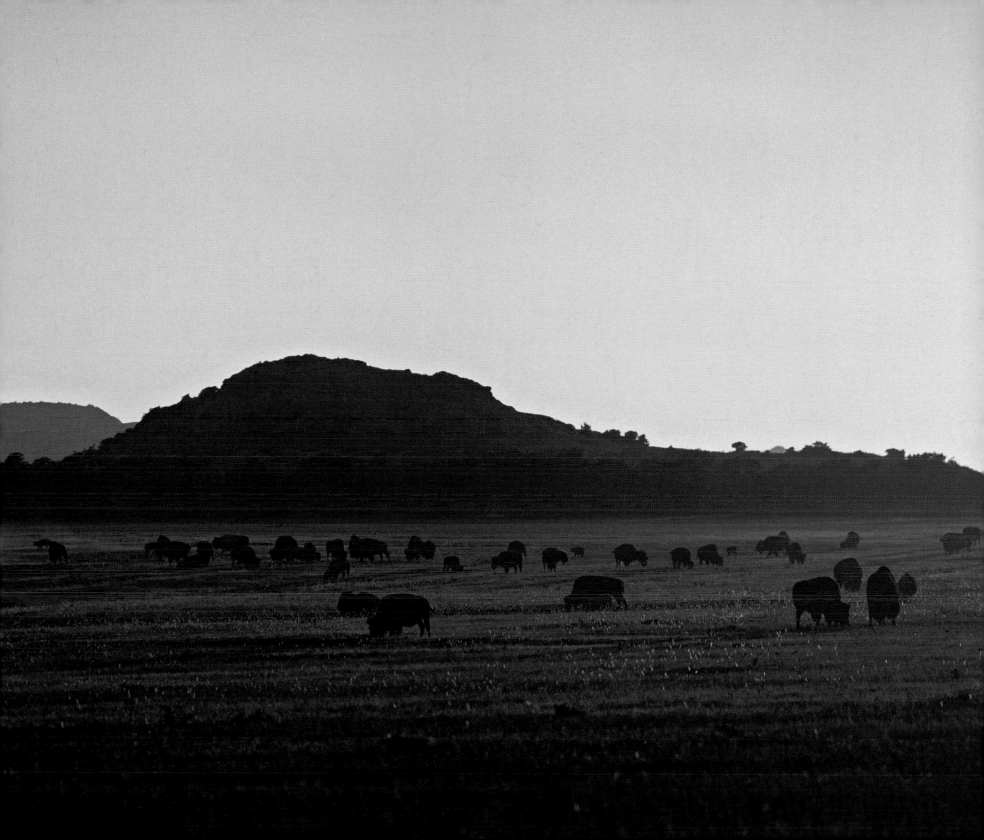

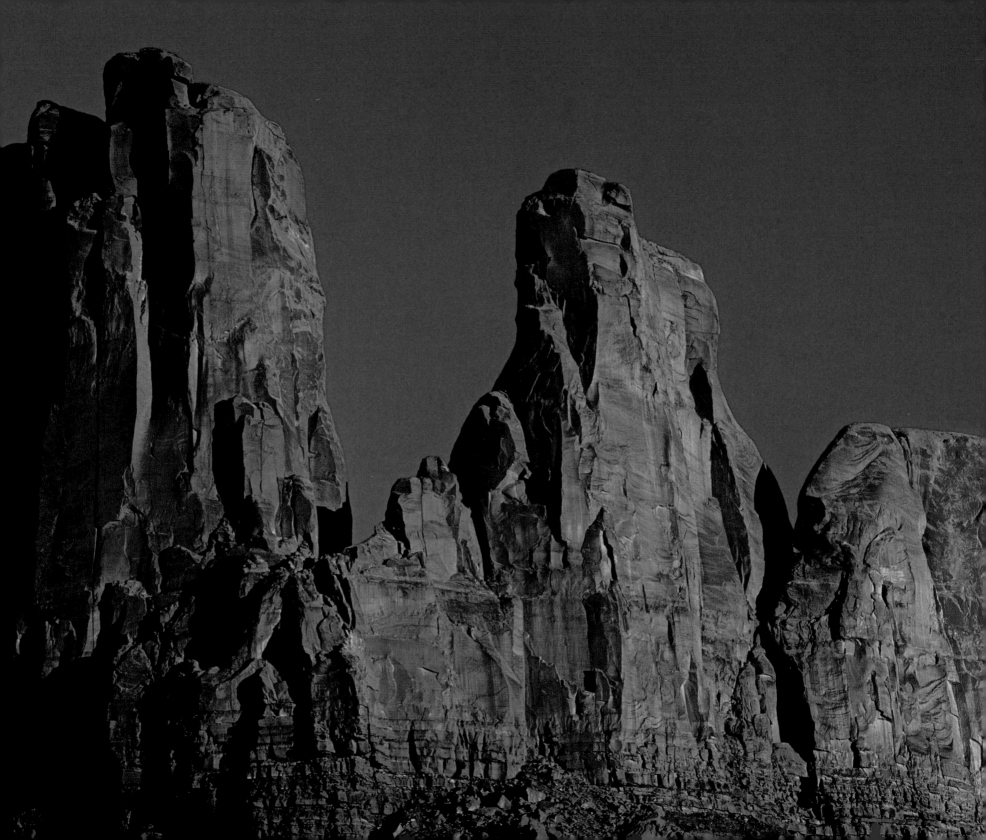

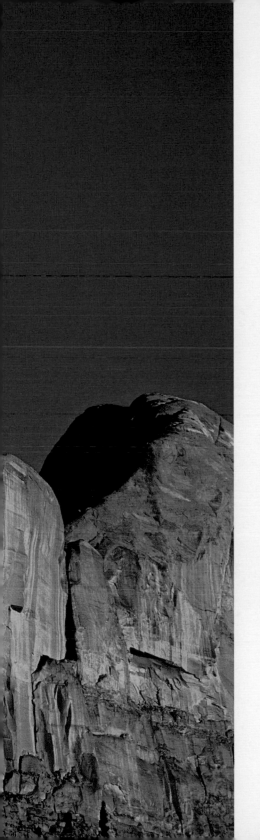

DINÉTAH & TUSQUA:

In the Land of the Diné *and* Hópi, *Navajo and Hopi*

CANYONS AND MESAS

"Each of these mountains has a story, prayer, song and ceremony. . .
And all are interconnected, including the sacred songs.
And within that sacred land we were born, and continue to be born.
And within this sacred land we will reach old age."
— FLOYD LAUGHTER, *Red Streak-into-Water Clan*

WE HAVE BEEN SEARCHING THE VALLEY FOR DAYS, PROBING DREAMY CANYONS and mesas for secret rainbows of stone that were said to wink from the heavens. It is high, red, almost barren ground, where tribal gods had dwelled for countless generations and where soaring pillars of sandstone turn my head in every direction. Most are sacred to the Navajo who view minarets like Three Sisters as *Haashch'eeh diné,* "Holy People," turned to stone. Spires I had never seen or imagined before soar from the pink talus and hold me rapt for hours as the setting sun burnishes them brown, red, pink, then blue, until fingers of rock like the Totem Pole and Yéi Becheii spires stand as giant prayer sticks against black heavens streaked with silver comets and stars. But none is more captivating to me than Skeleton Spires. Beckoned by immaculate walls and fissures flint-napped by the hands of the gods, the great stones towered over ancient sweat lodges used by medicine men who once sang to the rocks with prayers.

47

PREVIOUS PAGE: *Skeleton Ridge, Monument Valley, Arizona. The Navajo migrated into the Painted Desert region during the 1600s and forged a living beneath turquoise skies and spectacular landforms that resembled deities.*

Lost among the braided arroyos, cliffs of fossilized sand, and snakeweed, datura, and a cornucopia of other sacred plants that grew in *Tsé bii' Ndzisgaii,* "Clearings Among the Rocks," we continue probing mysterious canyons and lofty mesas masqueraded by the shape-shifting mirages of shadow and light. In the distance, in a red desert where every drop of clear water has meant life since the Old Ones first prayed here, a sunbeam streaks through a small window of stone. My guide, a mixed-blood Osage and Arizona native, maneuvers his truck through the soft, cinnamon-colored sand until we reach the hidden canyon. We get out of the truck. I look up. Zebra-striped ribbons of iron oxide streak down the terra-cotta walls. Carved by eons of wind, water, and ice, an oval eye peers down at us, exposing an iris of blue sky. "We found it," my companion says. "I'm going to go look for the other arch—I know it's up this canyon somewhere." Pulling down the sweat-stained brim of his cowboy hat, Bill Crawley walks through damp sand that tugs at the narrow heels of his lizard-skin boots, along the rim of a cut bank, closing in on a lifelong dream to discover the Painted Desert's red-rock rainbows.

Near the foot of the small stone window, a fragile pyramid of weathered timbers lays across a forked pole. It's the skeletal remains of a sweat lodge, a place of cleansing and prayer. I start to set up my tripod, but cold, dark clouds suddenly roll in over the rimrock. A blustery dervish of wind whirls around me, peppering my eyes with sand. I cover my face and spit sand out of my teeth, but the wind grows stronger, colder, and louder until I realize *ch'įįdii*—spirits—must still dwell here. Like *Ne'éshjaa',* "The Owl," believed to be a harbinger of death in many cultures, whirlwinds are also a bad sign in traditional beliefs. They can cause sickness that, in the case of the Navajo, is cured by healers singing the *Nílch'iji,* "Wind Chant." I heed the wind warning and fold up my tripod. Moments later, my partner returns, fearing a flashflood might roar down the canyon any moment.

We had just crossed over into the spirit world of Monument Valley. It wasn't my intention. I'd come to see the sacred landmarks the Navajo had revered since they migrated into the Painted Desert during the days of old. I had written their holy names in my notebook, and I'd asked patient Navajo I'd met to tell me how to pronounce them: *'Álá Tsoh, Tsé Ts'óózi,* and other names I longed to say without generating laughter. These were the same landmarks made famous by Hollywood motion pictures like *Stagecoach* and *How the West Was*

Won. They defined the West for the world to see, but the cinematic landscape was the antithesis of Navajo beliefs.

Sweat Lodge Arch, as I called the stone rainbow, and the dervish of wind that spun out of the sand near the foot of it, opened my eyes to Monument Valley in ways I had never seen before. I was about to discover that the Old Ones had also revered this land long, long ago. Their fragile signs were everywhere, but they were overshadowed by the hypnotic sweep of the most revered and hauntingly beautiful scenery in the world.

Grim, gray clouds that had stalked us for days give way to crisp blue skies the afternoon we enter Mystery Valley. Aptly named, this was also home to ancestral Puebloans the Navajo called *Anaasází,* "Enemy Ancestors," and the Hopi called *Hisat.sinom,* "People Who Lived Long Ago." They dwelled in Mystery Valley, Monument Valley, and elsewhere throughout the Four Corners region long before the Navajo sang the Beautyway beneath the red rocks and turquoise skies.

It is late afternoon. The setting sun paints the cliff face a luminous pink. The air is still and quiet—and the rocks begin to speak. I walk toward a small stone dwelling, mortared together with mud beneath a sheer, overhanging cliff next to a ceremonial kiva. Scores of white handprints that resemble flower petals lace the pink walls around the roofless dwelling. A Paiute woman once told me similar handprints I'd seen in the Grand Canyon were left by

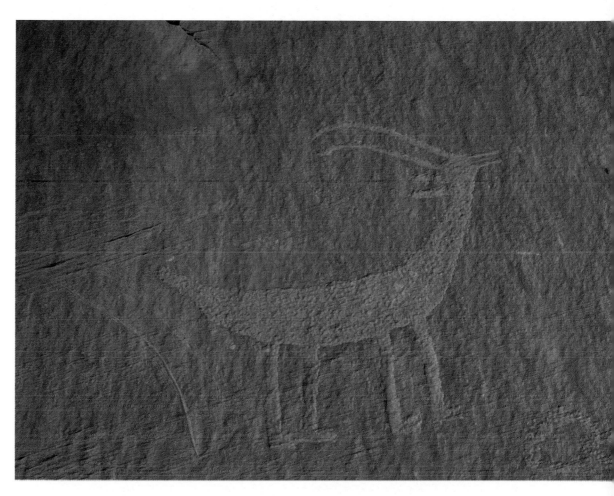

ABOVE: *Bighorn sheep petroglyph, Monument Valley, Arizona.*

OVERLEAF: *Flight of a shaman, Mystery Valley, Arizona. Etched into a mesa cliff this mystifying bird may, as one anthropologist wrote, "symbolize the shamanic power of magic flight."*

not fathom such practices. On such sacred ground, archaeology has always struck me as sacrilegious.

In the fleeting moments of the evening sun, I notice a mystifying carving: A long-beaked bird had been etched into the fire-hardened brimstone. Anthropologists suggest, "Birds may symbolize the shamanic power of magic flight; the bird may lead the soul in flight, or the soul may actually change into a bird." I wonder where this shaman's dreams may have taken him. There were many such places, I discovered, where he may have gone.

The dreams may have taken him to Canyon de Chelly, what the Hopi call *Koyòngkuktupqa,* "Turkey Tracks Canyon." The *Hisat.sinom,* and later the Hopi, dwelled throughout canyons of such rare beauty; they lived in Canyon de Chelly and Canyon del Muerto for thousands of years, among venerated cliff dwellings like White House Ruin that were nested on the ledges of precipitous canyon walls. When the Navajo moved into the same fertile canyons they called *Tséyi',* "In Between the Rocks," around A.D. 1700, medicine men performed the Night Chant ceremony at the cliff dwelling they revered as *Kin níí' na'igaih,* "White House In Between." It was the home of supernatural beings called *Yéii.* Like Mystery Valley, White House Ruin and others here also bore handprints and symbols and held sacred burial cists. By any name, Canyon de Chelly is hallowed ground for Hopi priests who still make pilgrimages to White House Ruin and the Navajo who still use ancient toeholds to scale the thousand-foot high canyon walls that continue to weave their fabric of life.

The shaman's dreams may have taken him to *Kawéstima,* "Village in the North," where Hopi elders continue to revere their ancestral village and the sacred *Kókopnyam,* "Fire Clan," symbol of *Másaw,* "Guardian of the Underworld." Here, too, the white handprints can still be seen.

Or the shaman's dreams may have taken him to *Tutuventiwngwu,* "Place of the Clan Rocks," where many generations of Hopi carved sacred clan inscriptions that date back long before the the *Kastíila* (Spaniards) and *Pahaanna* (Anglos) arrived in the Painted Desert.

The shaman's dreams may have taken him to many such places in *Dinétah* and *Tusqua.* Mine kept bringing me back to Monument Valley. Beyond the cinematic smokescreen, I'd seen powerful evidence the *Anaasází* and *Hisat.sinom* sought supernatural forces among the storied monuments. It is still evident at places of transformation like Sweat Lodge Arch.

I see it at Honeymoon Arch, where a prehistoric granary nestles beneath a dome of rock. I see it on the lip of a small cave, where life-sized handprints and sandal tracks have been pecked into the floor with a hammer stone and chisel. I see it at Big Hogan Arch, where faint white handprints grace the walls water-stained with the fifty-foot-tall supernatural figure of a *Yéi Becheii*. I see it in yet another hidden canyon, where *Kokopeli,* named for the Hopi Kachina called *Kókopilau,* "Humpbacked Flute Player," had been chiseled into the patina of a rock face—one of hundreds that have been reportedly seen from Canada to South America. And I see it at Cly Arch, where the remains of a small dwelling give way to the morning view of a landscape burned orange by the rising sun.

It is late afternoon when I drive the postcard highway north from Monument Valley to Mexican Hat, Utah. The pink sun winks through eyelids of blue clouds clinging to Eagle Mesa. Here, it is said, "the spirit of a dead person goes after burial." The spirit grounds loom over *Dinétah* and *Tusqua,* what elders have said for many generations is sacred ground. Here, far from the great ant doings of modern civilization where archaeologists once dug up their souls, the Old Ones sang to the sun, moon and stars that continue to bless the red rocks. Some are shaped like rainbows, others like prayer sticks and Holy People. Many remain hidden in deep canyons, where tribal gods still dwell.

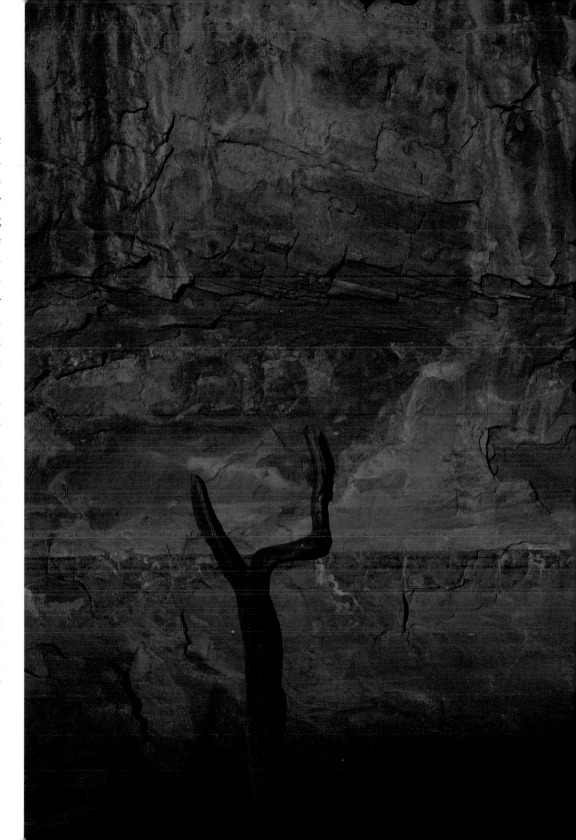

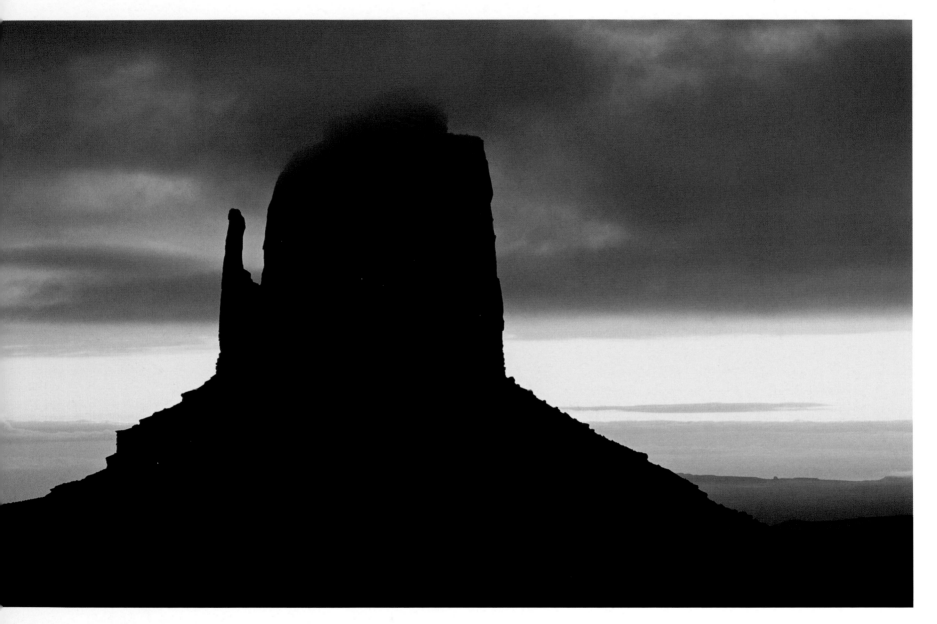

*East Mitten Butte, Monument Valley. 'Álá Tsoh, "Big Hands." Heralding dawn
rain, ground fog enshrouds the iconic landmarks of Monument Valley, blessing the
Navajo who still herd sheep and goats in the harsh and beautiful high desert.*

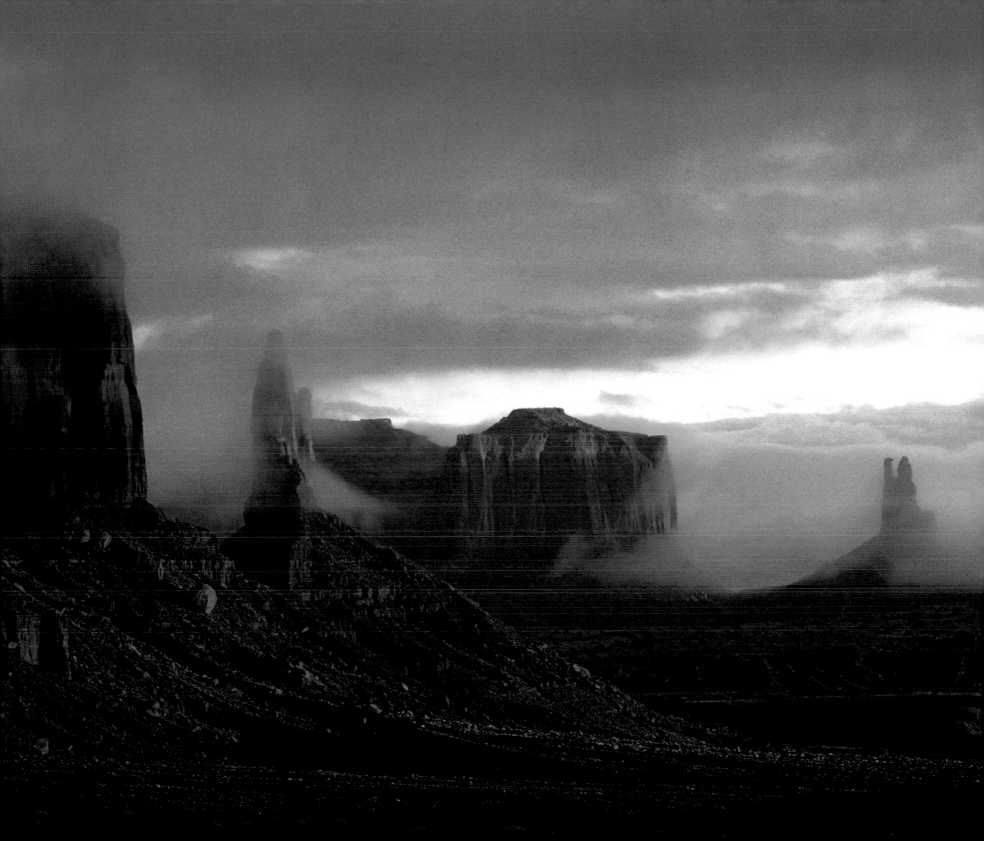

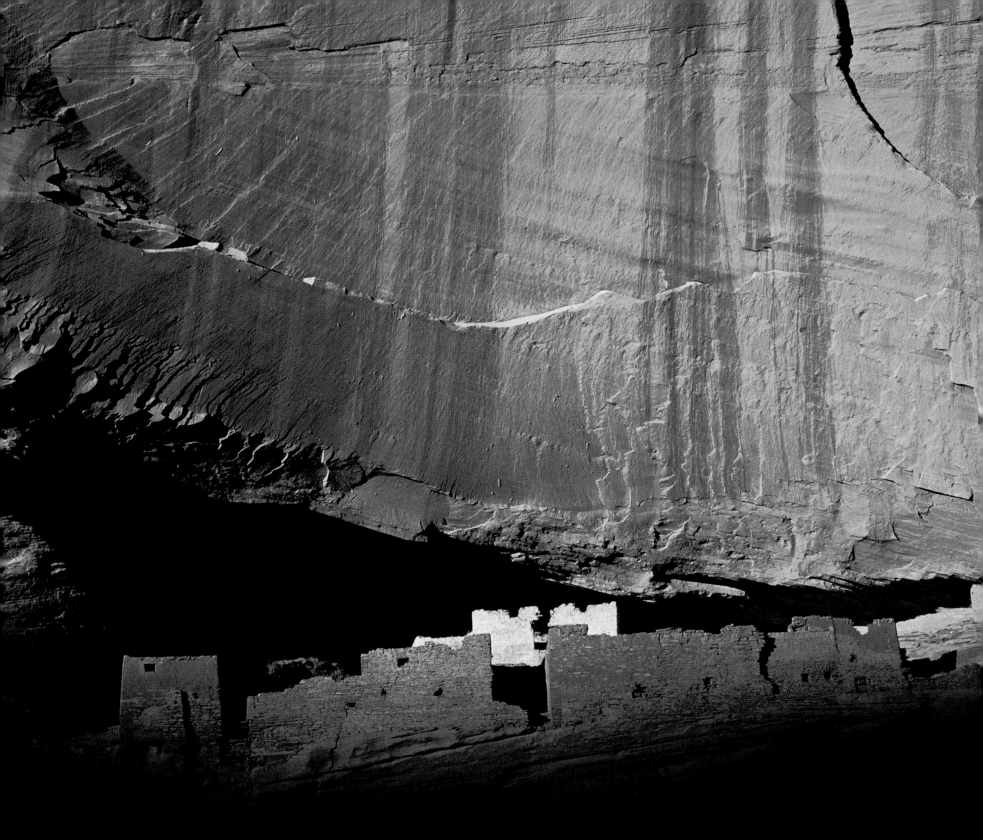

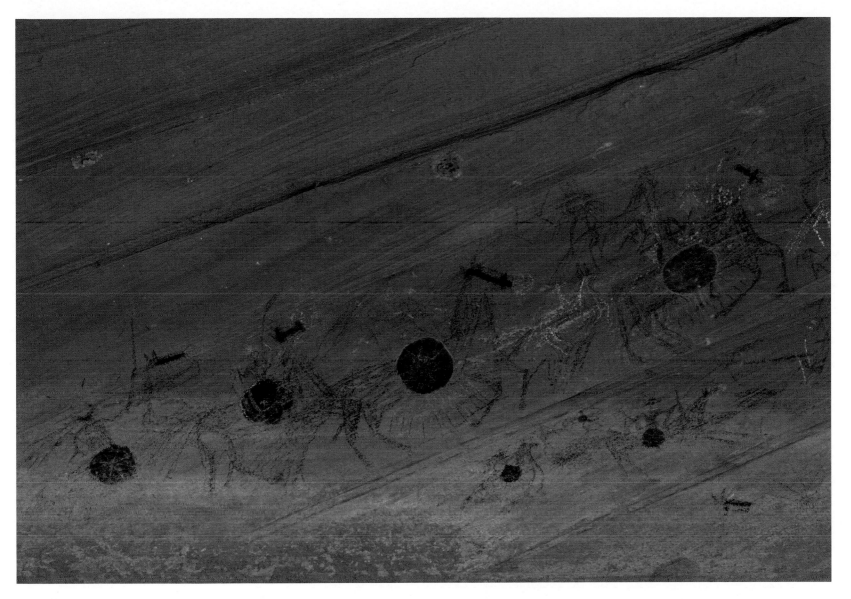

OPPOSITE: *White House Ruin, Canyon de Chelly, Arizona.* Kin níí' na' igaih, *"White House In Between,"* was built by ancestral Puebloans in A.D. 1066 and was later occupied by the Hopi, who lived in what they called Koyòngkuktupqa, *"Turkey Tracks Canyon,"* until the Navajo moved into the area in the 1700s.

ABOVE: *Ute Fight Mural, Canyon del Muerto, Arizona.* This charcoal-drawn mural called Nóódá'aktii' Bił Yikahigi, *"More Than Three Utes Which Ride Along on Horses,"* depicts an attack by Ute warrior Tsíí łigai, *"White Hair,"* and forty horseback Utes who raided the Navajo for slaves and livestock during the 1840s.

Navajo code talker Eddie Draper at the Spider Rock overlook, Canyon de Chelly, holds (OPPOSITE) *a 1944 photo of two buddies who fought alongside him during War War II.*

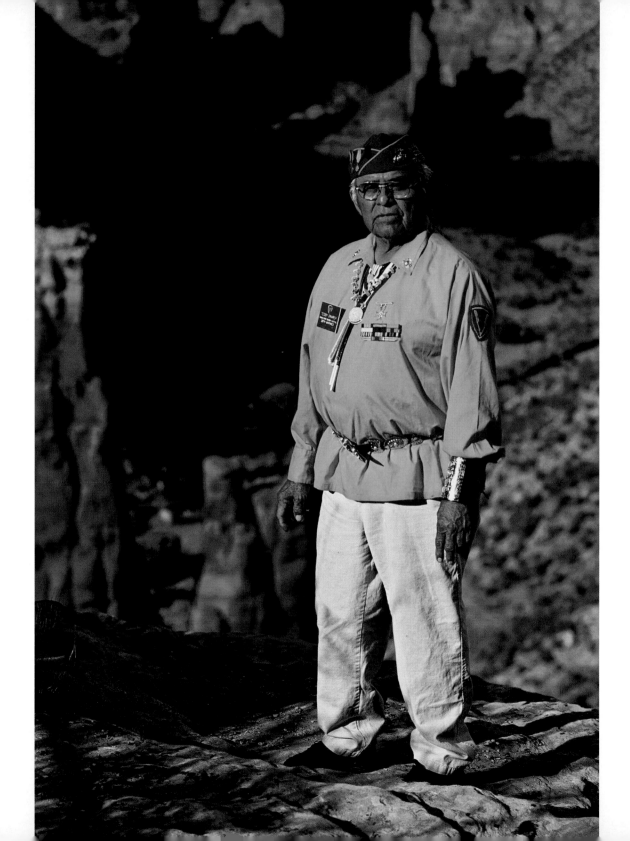

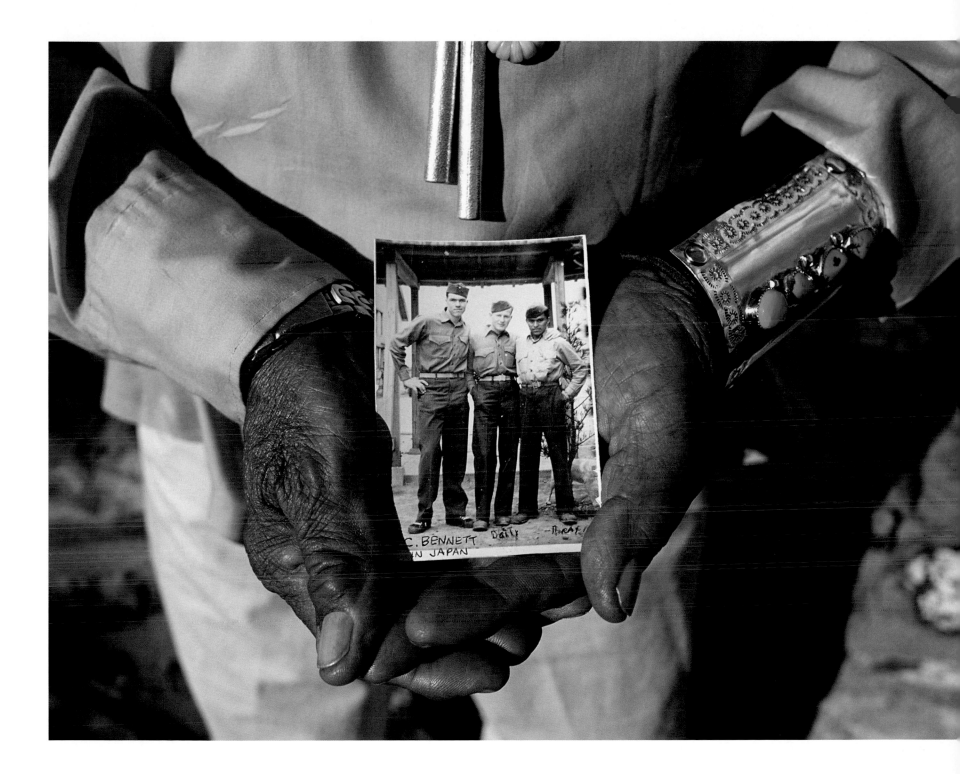

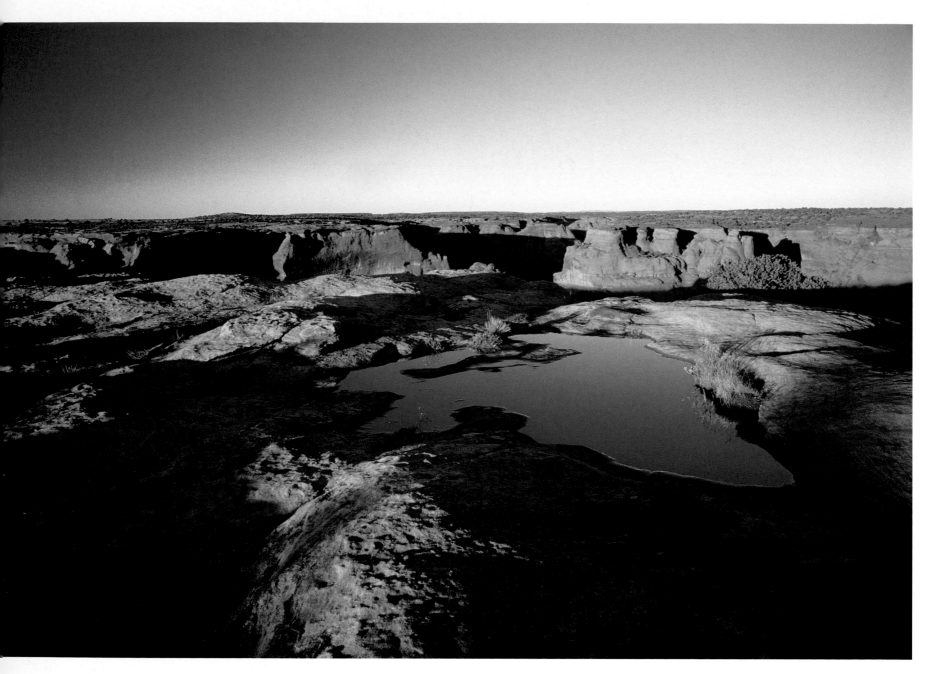

Waterpocket, Canyon de Chelly. Summer monsoons fill rimrock water pockets that sustain the Navajo during journeys between sheep camps on the canyon floor of what's called Tséyi', "In Between the Rocks."

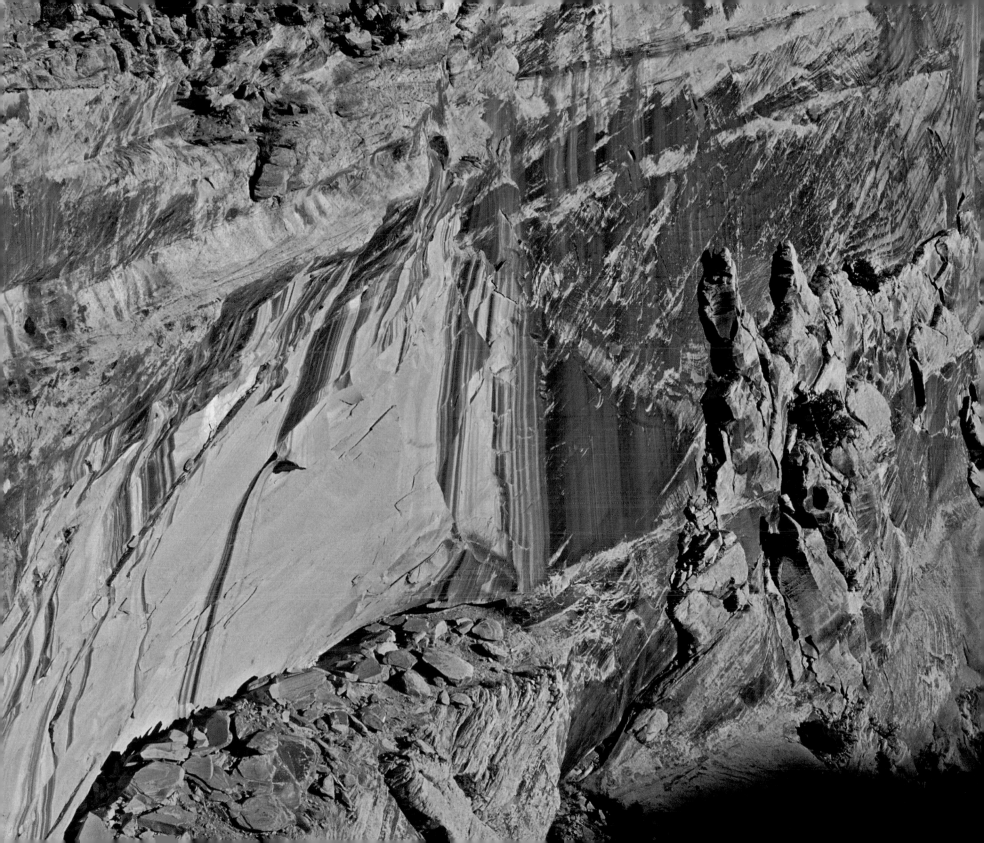

62

PREVIOUS PAGE: *Massacre Cave, Canyon del Muerto, Arizona. Lead by Lieutenant Colonel Antonio Narbona in 1805, Spaniards, Mexican Ópatas, and American Zunis opened fire and slaughtered seventy Navajo women and children on this precipitous ledge (called Naa'azhníídee'é, "Where Two Fell Off")—but not before a daring Navajo woman scaled the canyon walls and dragged a Spanish soldier to his death.*

OPPOSITE: *Handprints, Big Hogan Arch, Monument Valley, Arizona. Handprints at the foot of Big Hogan Arch* (RIGHT) *was convincing evidence that ancestral Puebloans sought supernatural forces beneath this red-rock arch that's water-stained with the supernatural figure of a* Yéi Becheii.

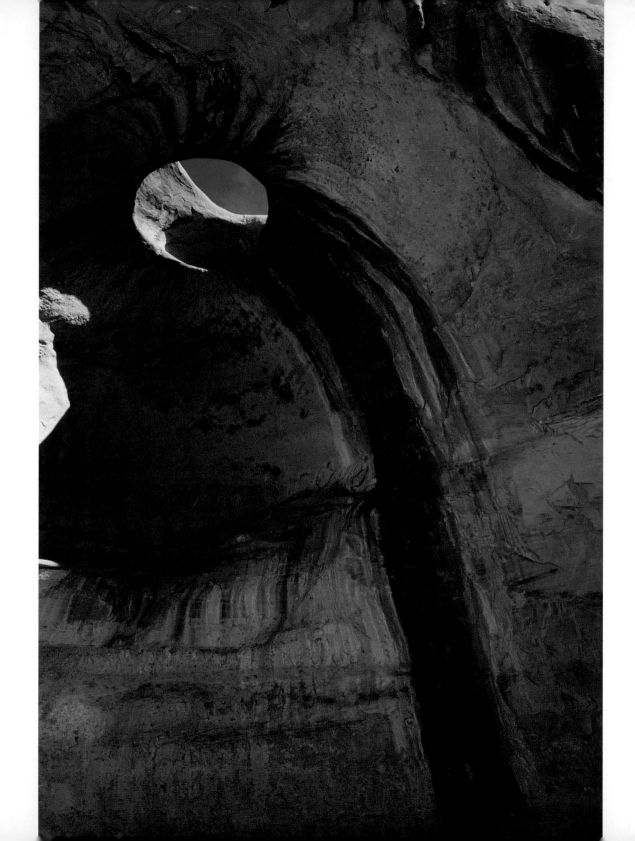

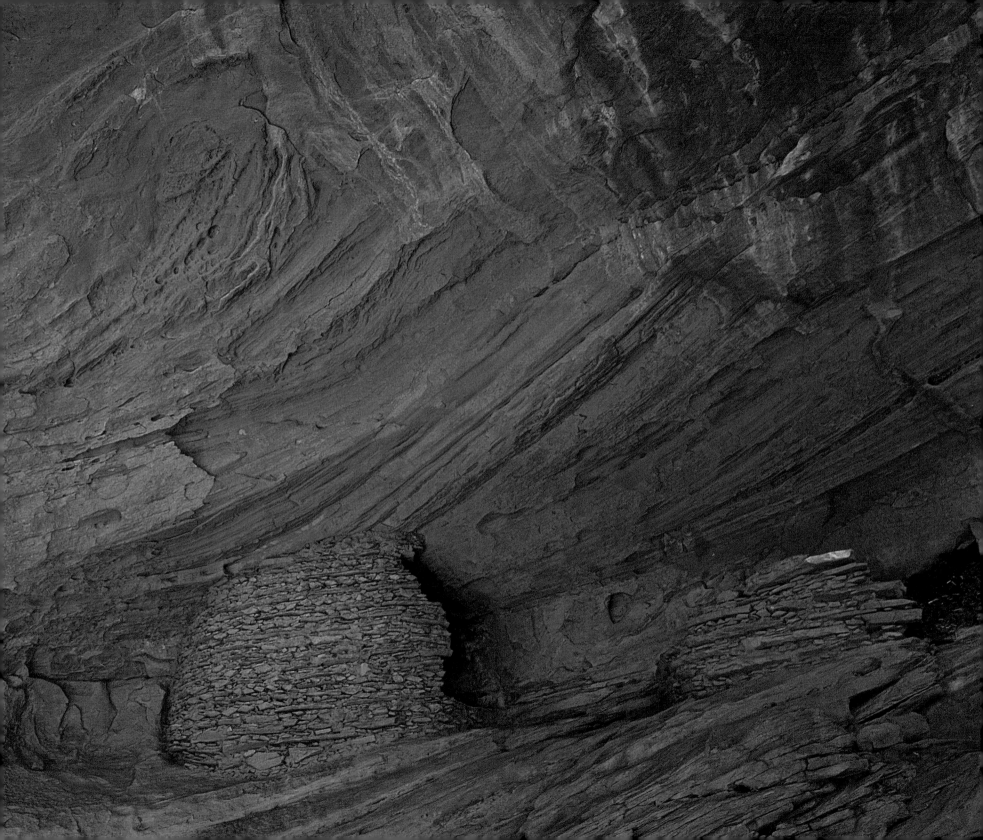

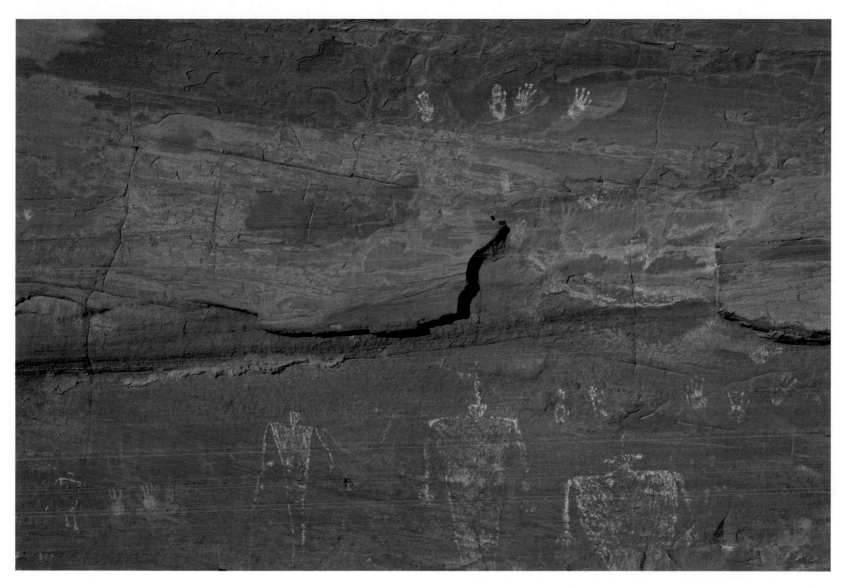

OPPOSITE: *Honeymoon House, Mystery Valley, Arizona. Convinced that ancestral Puebloans were short statured, early visitors mistakenly named this storage granary Honeymoon House.*

ABOVE: *Shamans dreams, Mystery Valley, Arizona. This gallery of handprints and medicine men gives credence to beliefs that Mystery Valley was a powerful loci for shamans.*

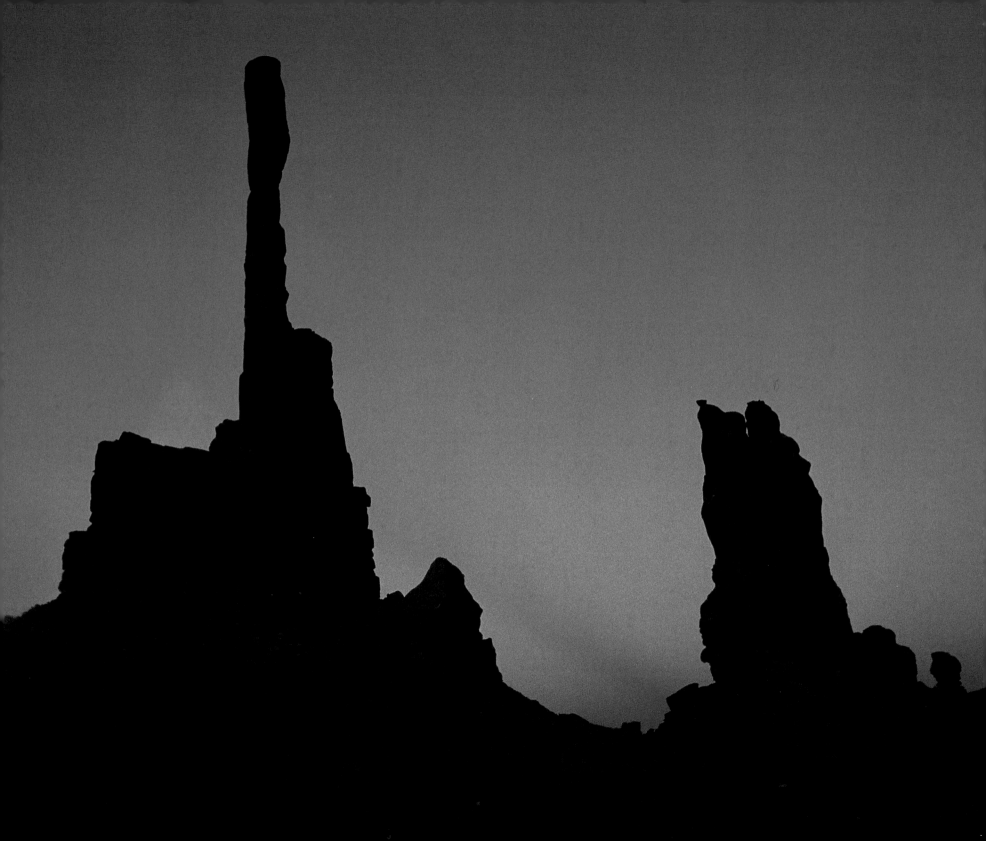

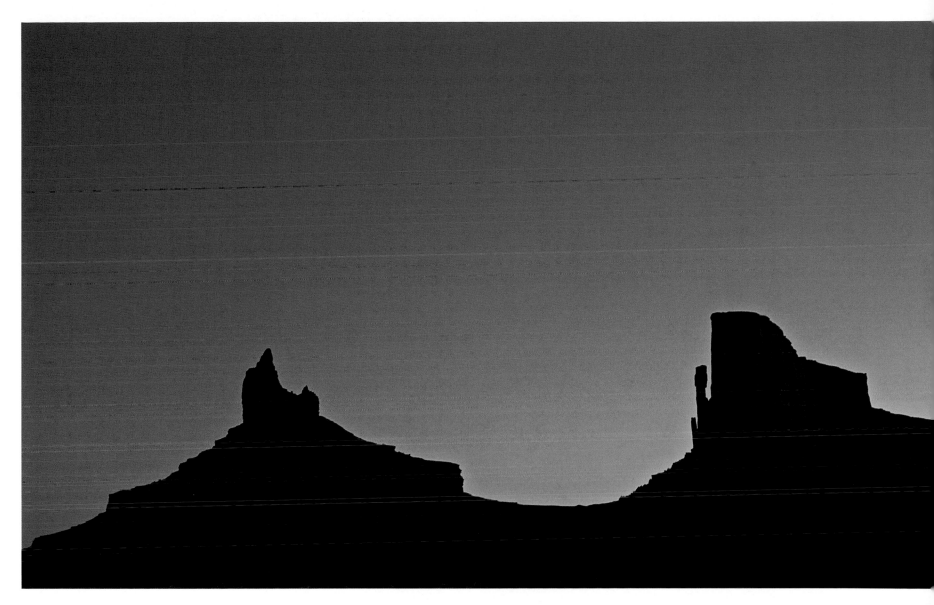

Rooster Rock and Meridian Butte and (OPPOSITE) *Totem Pole and Yéi Becheii spires, Arizona. Stretching between distant landmarks, Monument Valley, known as* Tsé bii' Ndzisgaii, *"Clearings Among the Rocks," encompasses one hundred square miles of the most revered and hauntingly beautiful scenery in the world that the Navajo view as a giant hogan.*

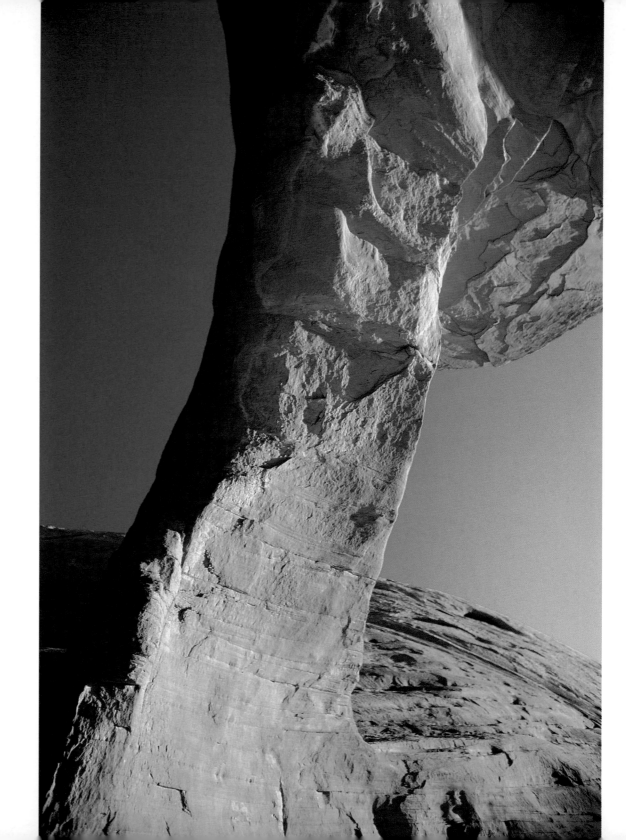

Cly Arch, Mystery Valley. Monument Valley's many sacred landmarks include Cly Arch, named for Navajo leader Tł'aa'í, *"Left Handed," as well as* (OPPOSITE) *the six-hundred-foot high Totem Pole. Known as* Tsé Ts'óózi, *"Slim Rock," it's said to resemble a Navajo prayer stick.*

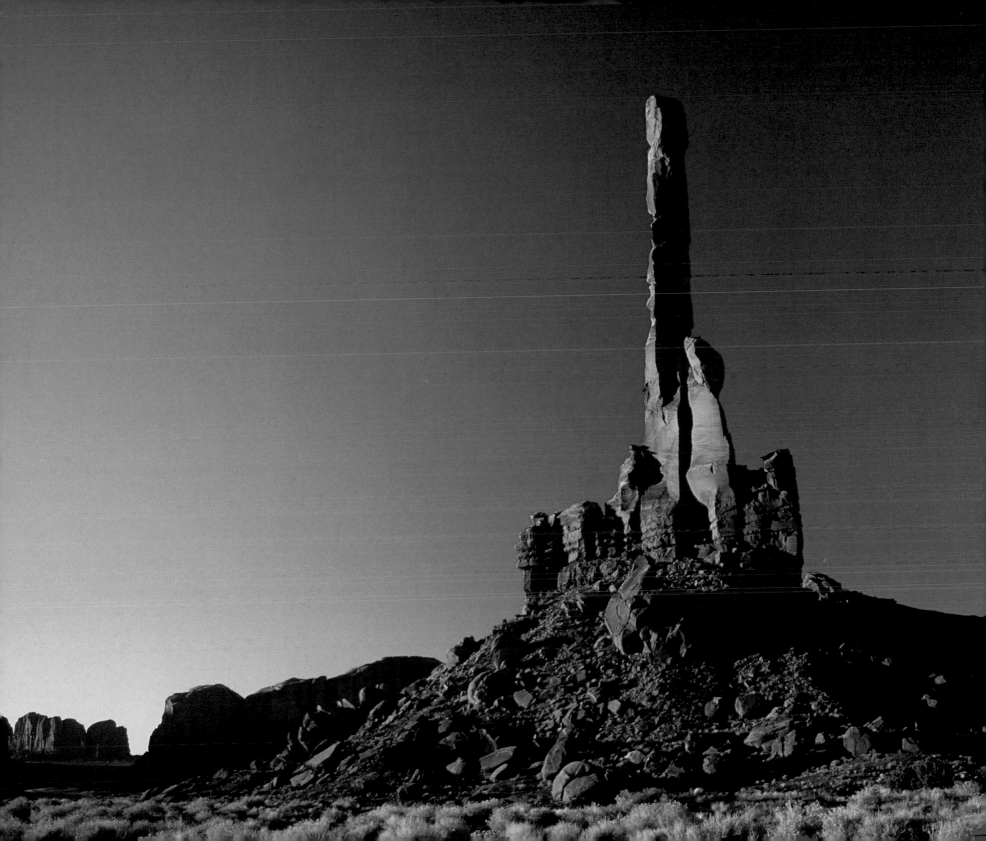

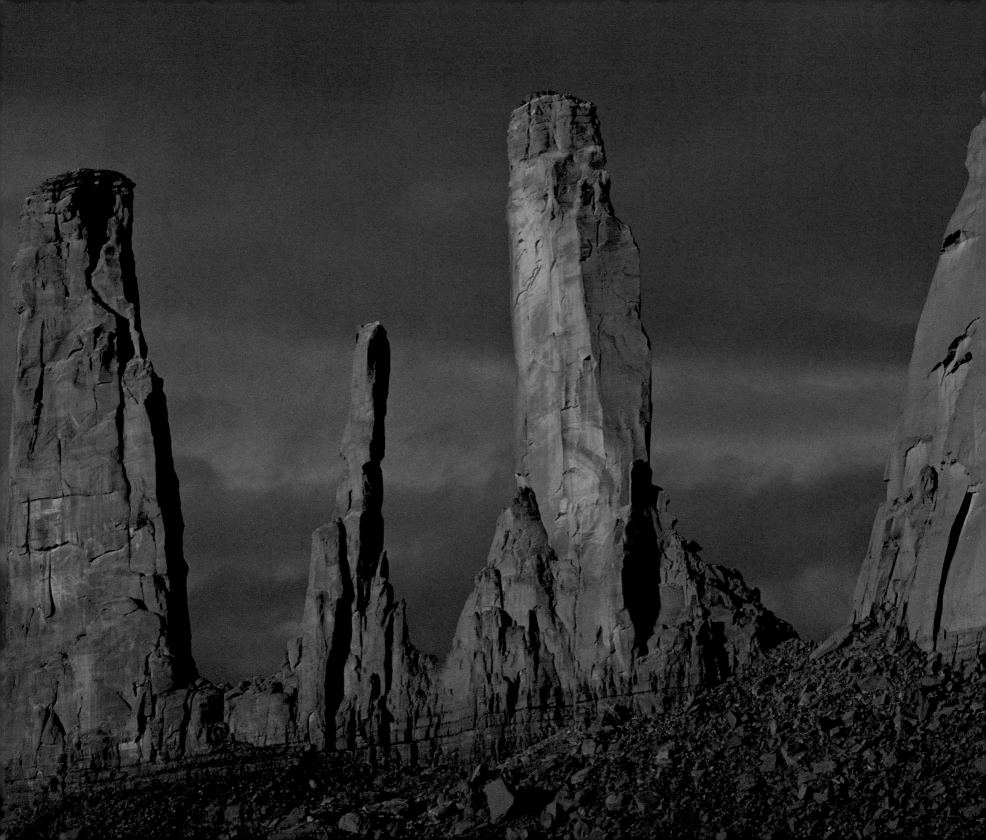

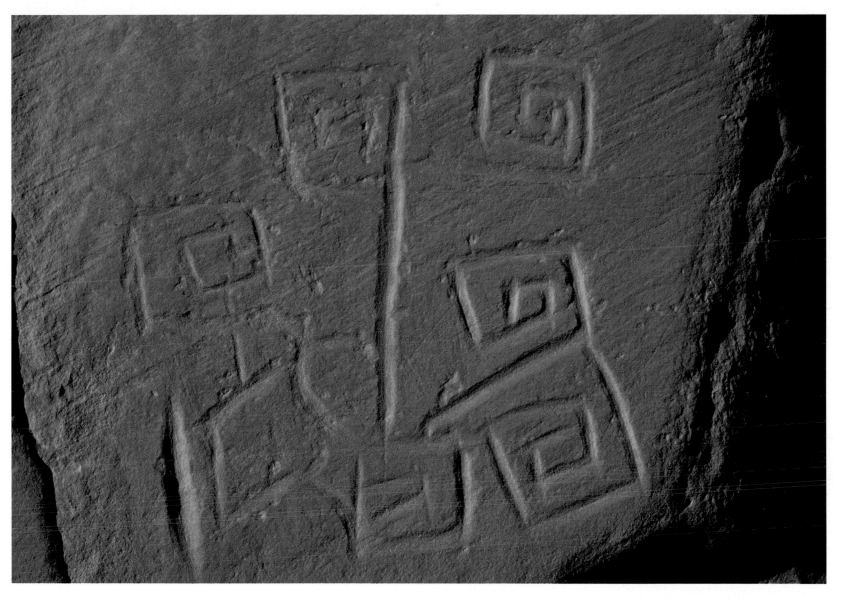

Holy People, Monument Valley, Arizona. Among the other extraordinary land-marks that form the Navajo's spiritual geography are the Three Sisters, soaring six hundred feet above ancient petroglyphs (ABOVE) *incised in DeChelly Sandstone. Medicine man Billy Yellow told historians, "The Three Sisters are three Holy People who were turned to stone."*

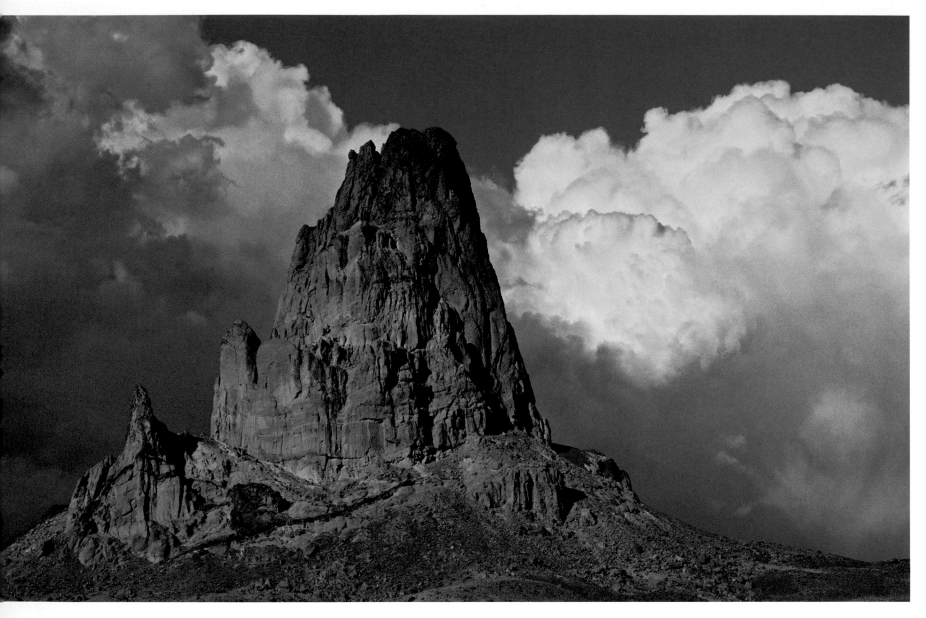

Agathla Peak, Little Capitan Valley, Arizona. Linked to the Navajo's ceremonial Bead Chants, Aghaa'łá, "Much Wool," describes how early hunters covered the peak's lower slopes with hair by scraping deer hides on the volcanic rock.

Summer monsoons, Navajoland, Arizona. Ignoring warnings to leave Monument Valley, prospectors James McNally and Sam Wolcott were killed by Navajo leader Hashké Neiinihí Biyé' *(Hoskinnini Begay), near Agathla in 1884.*

74

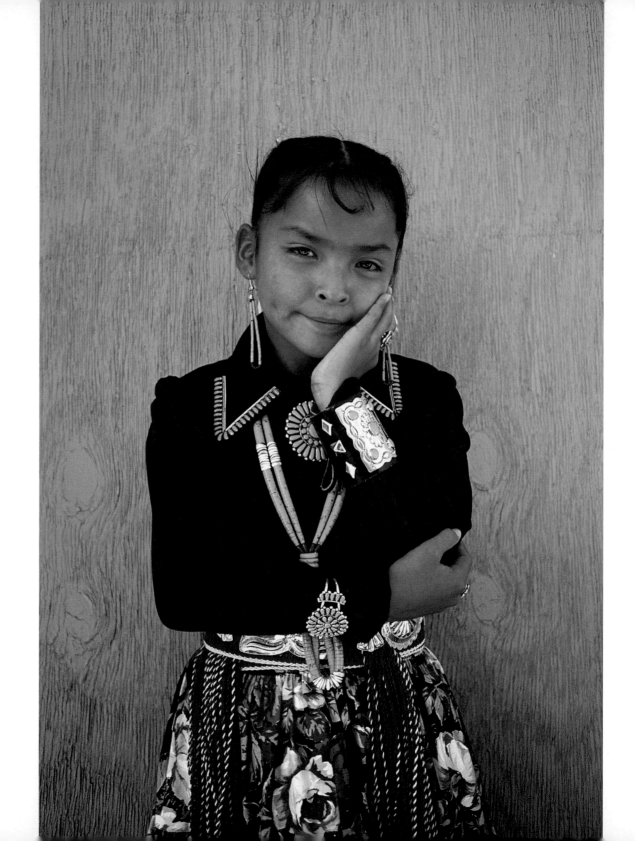

Lynn Cleveland, Window Rock, Arizona. Dressed for traditional song and dance, a young girl wears handcrafted turquoise and silver jewelry prized by the Navajo since the 1800s, including elders like ninety-two-year-old Suzie Yazzie (OPPOSITE), who's been weaving the dreams of her ancestors in Monument Valley since her youth.

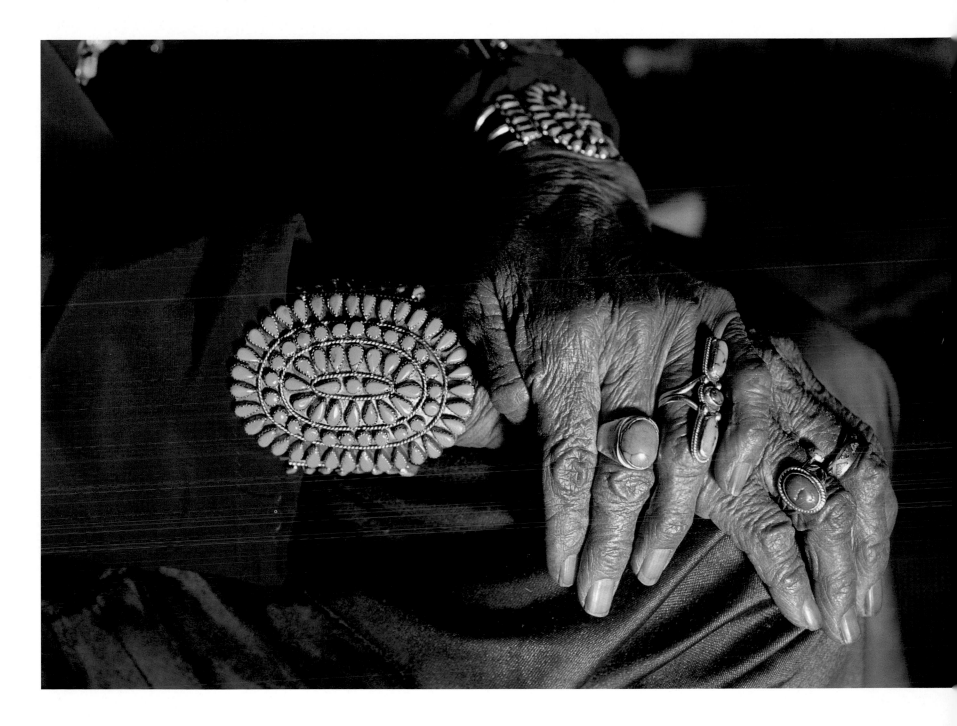

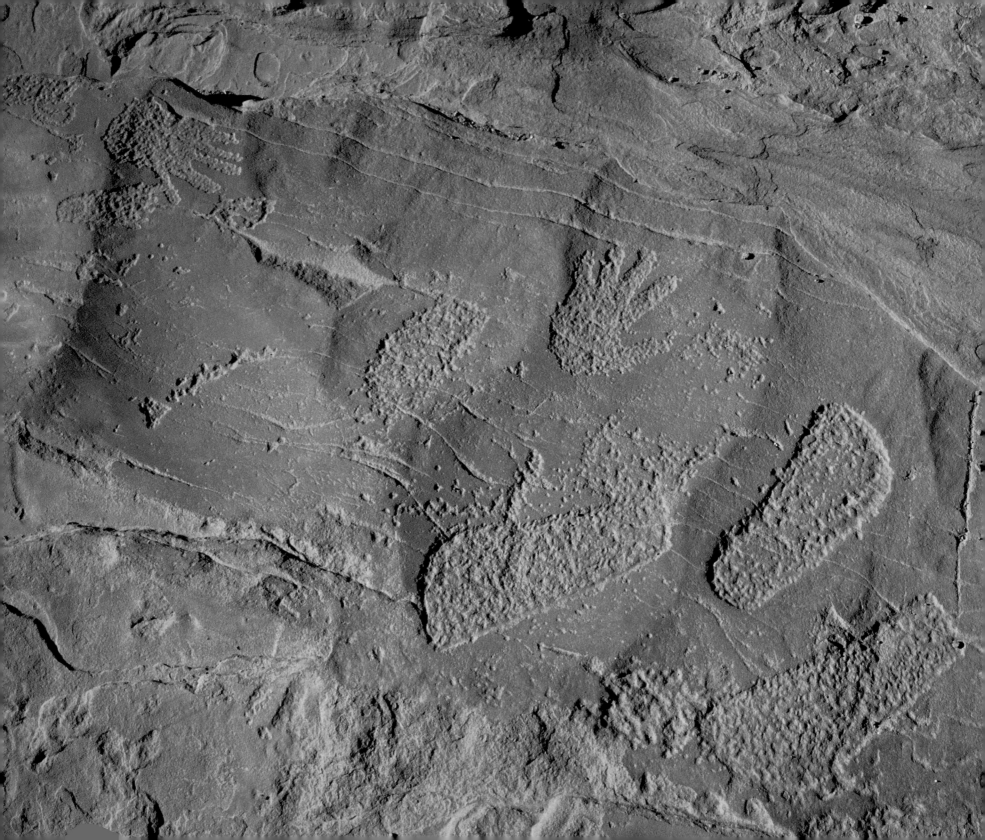

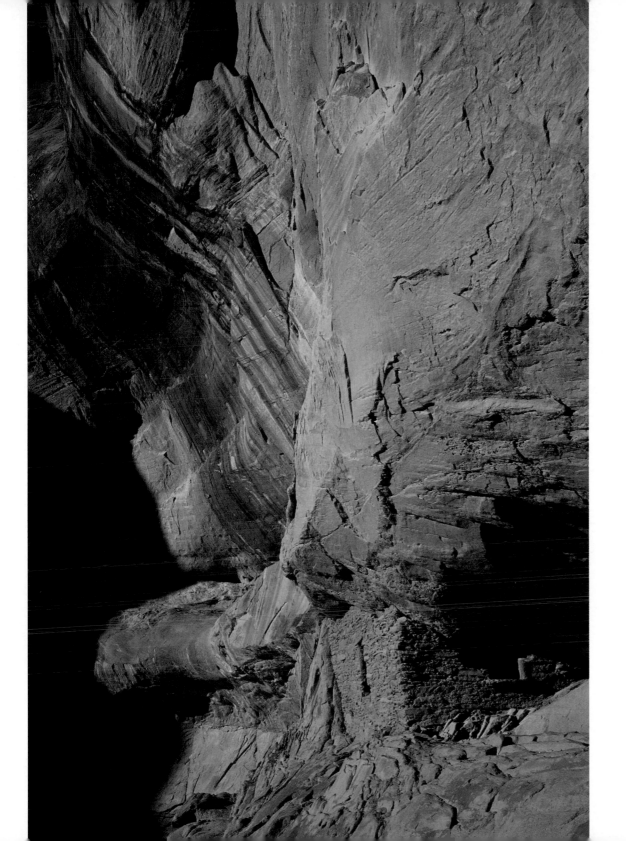

OPPOSITE: *Cave Floor Petroglyphs, Monument Valley, Arizona. Unique among Monument Valley's mystifying petroglyphs are handprints and sandal tracks that were pecked into this floor with a hammer stone and chisel.*

LEFT: *Firestick House, Mystery Valley, Arizona. Named in 1914 by Peabody Museum archaeologists Alfred Kidder and Samuel Guerney; the pair explored, excavated, and—against Navajo and Hopi spiritual beliefs—dug up skeletons from the area.*

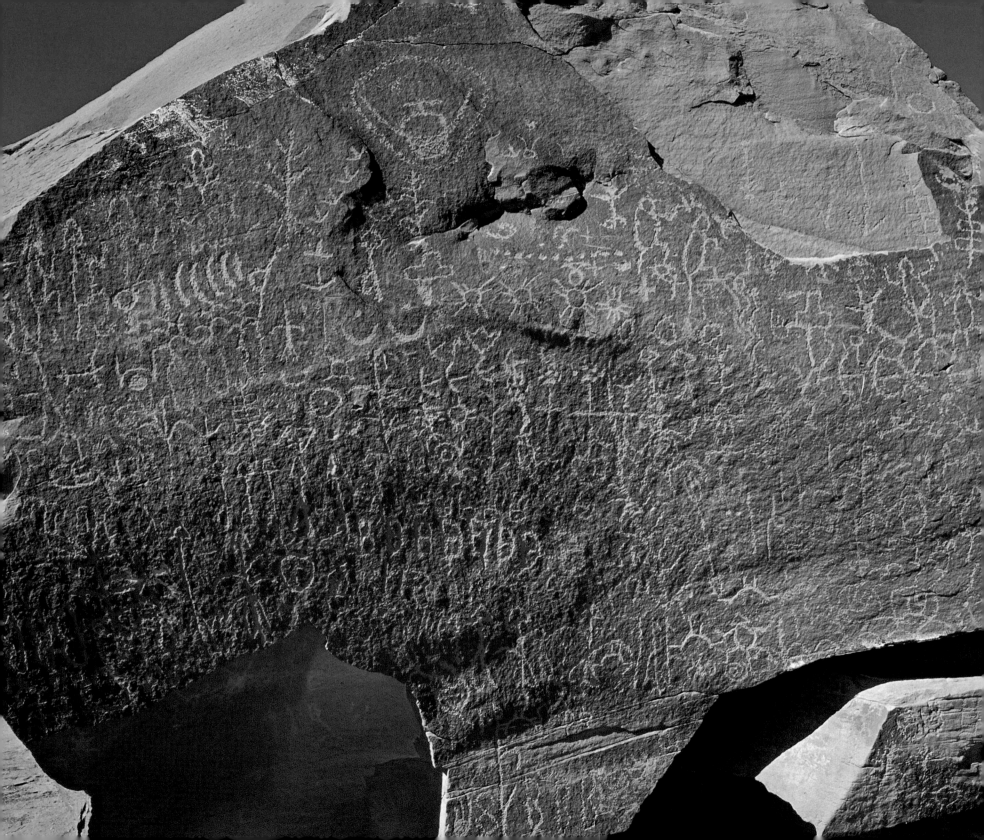

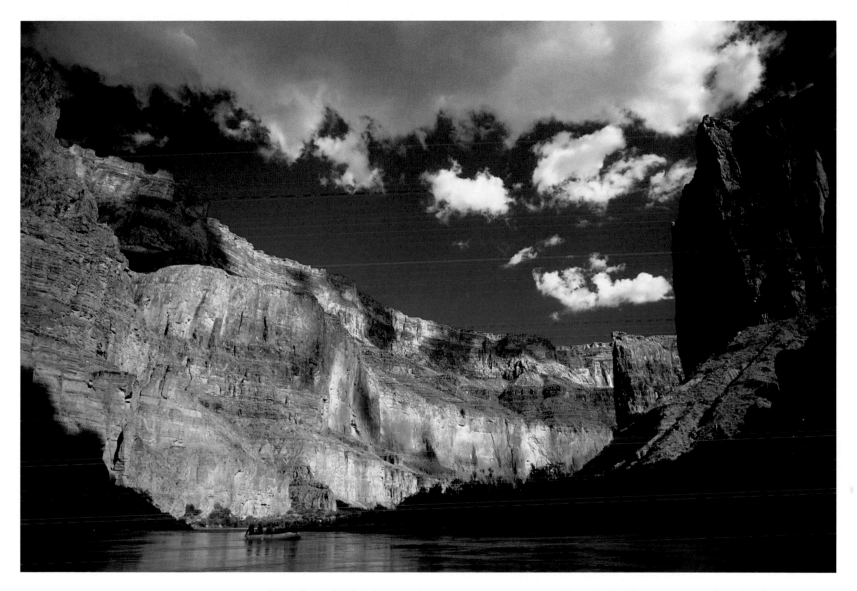

Hopi shrine, Willow Springs, Arizona. Tutuventiwngwu, *"Place of the Clan Rocks," is adorned with sacred inscriptions of the Bow Clan, Spider Clan, and others that date back long before the arrival of outsiders. Hopi men etched their clan symbols here during dangerous pilgrimages to collect salt in* Öwngtupka, *"Salt Canyon," what Hopis called the Grand Canyon* (ABOVE). *Following the route of the mythical Hopi snake hero* Tí-yo, *who navigated* Pısísvaiyu, *"Where Water Flows," modern river runners paddle down the Colorado River in Marble Gorge.*

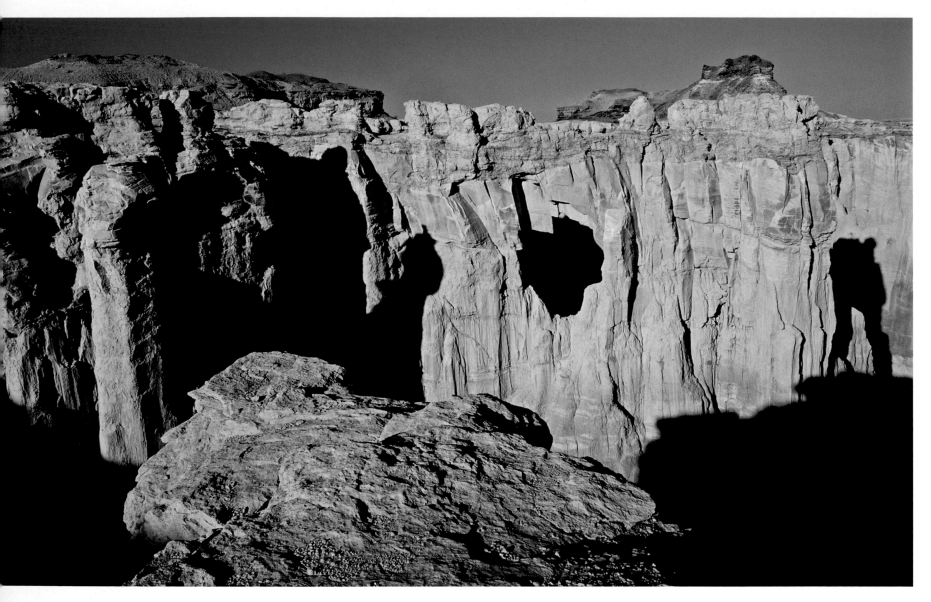

Coal Mine Canyon, Moenkopi Plateau, Arizona. Hopi pilgrims traversed remarkable landforms like Coal Mine Canyon, called Hoongi, *"Standing Up," on foot en route to the Little Colorado River Gorge* (OPPOSITE)*, where they paid homage at* Sipápuni, *the "Place of Emergence," during their hundred-mile journey to collect salt.*

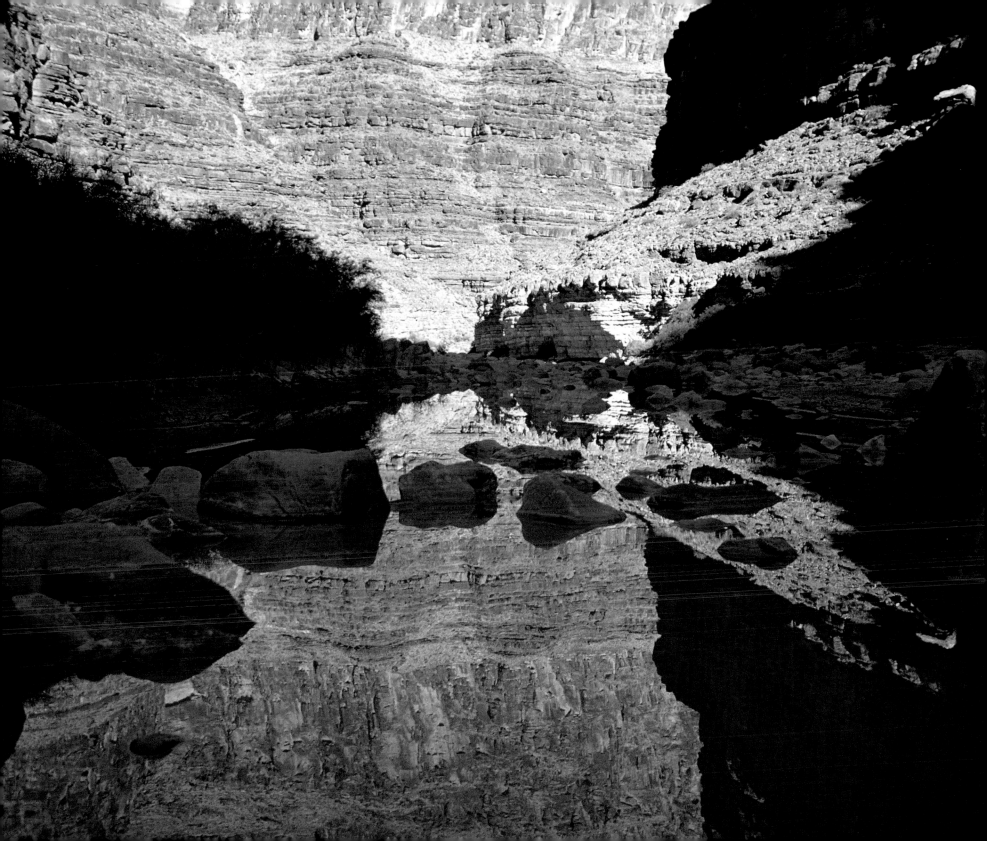

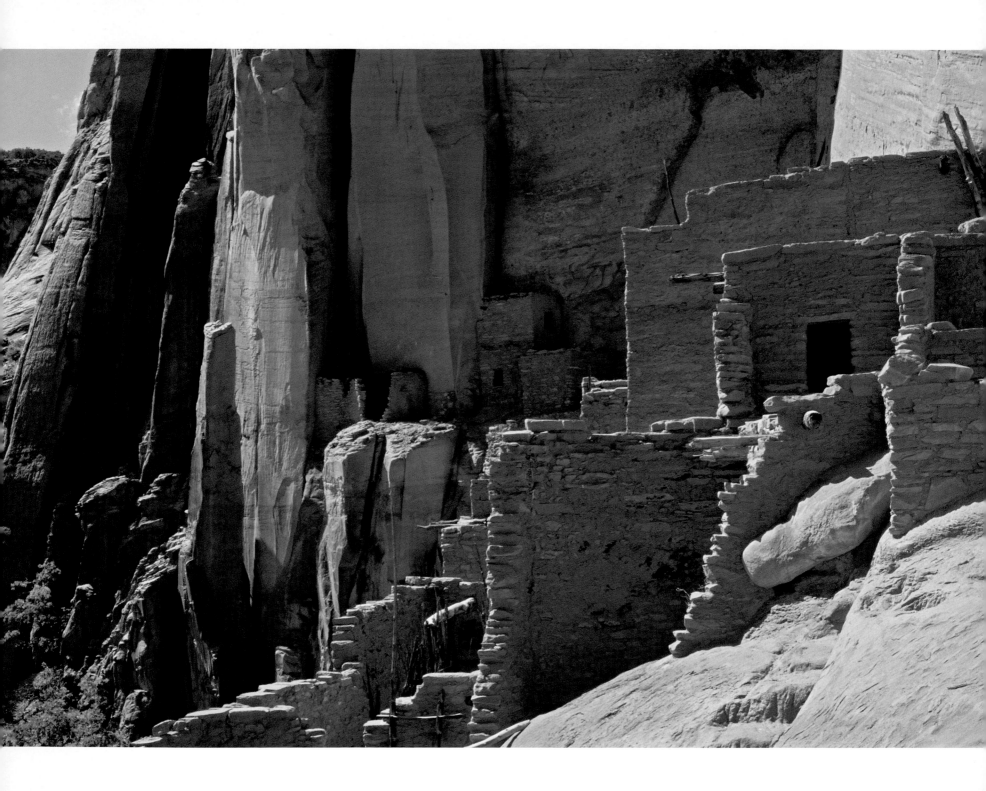

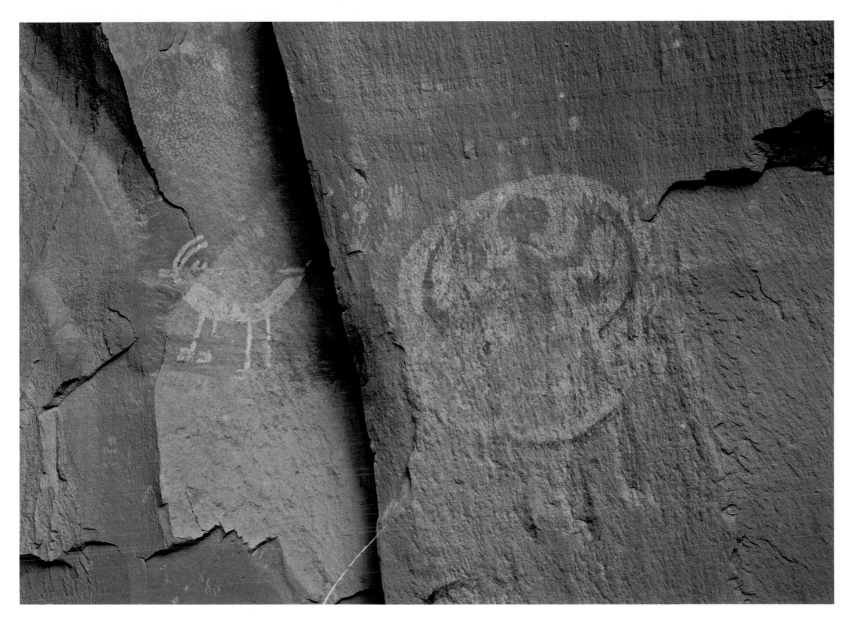

OPPOSITE: *Betatakin, Navajo National Monument, Arizona. Now located in Navajoland,* Kawéstima, *"Village in the North," is still visited by Hopi priests, who revere their ancestral village and* (ABOVE) *the sacred* Kókopnyam, *"Fire Clan," symbol.*

OPPOSITE: *Twilight, Monument Valley, Utah. Few sunsets are as soul stirring as those in Monument Valley where Eagle Mesa* (ABOVE) *beckons "the spirit of the dead."*

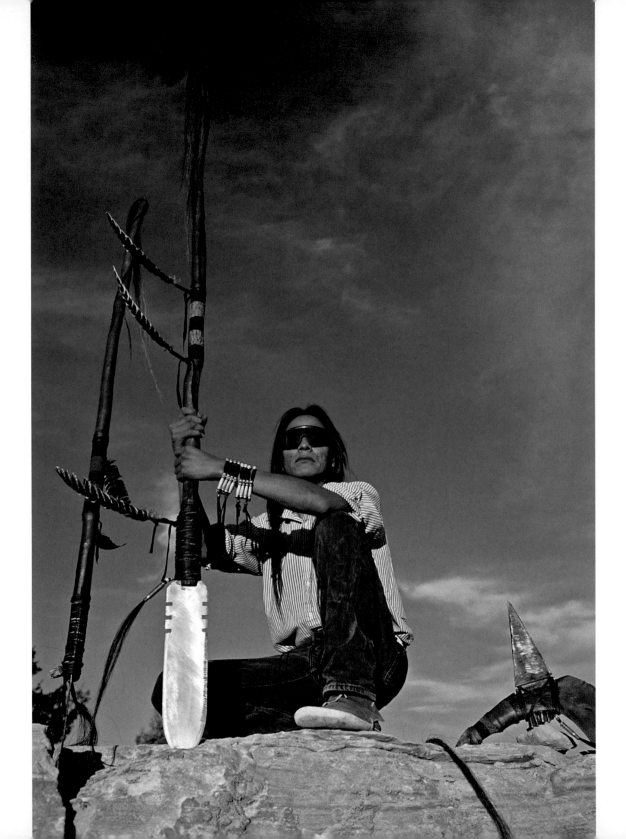

Richie Aski-Ei-Bah *"War Pony"*
Anderson, Window Rock, Arizona.
Perched on the edge of the rimrock, War
Pony is a traditional weapons maker.

OPPOSITE: *Powwow traditional dancer,*
Window Rock. Steeped in ceremonial
traditions linked to their origins, an
increasing number of Navajo have
adopted Powwow into their culture.

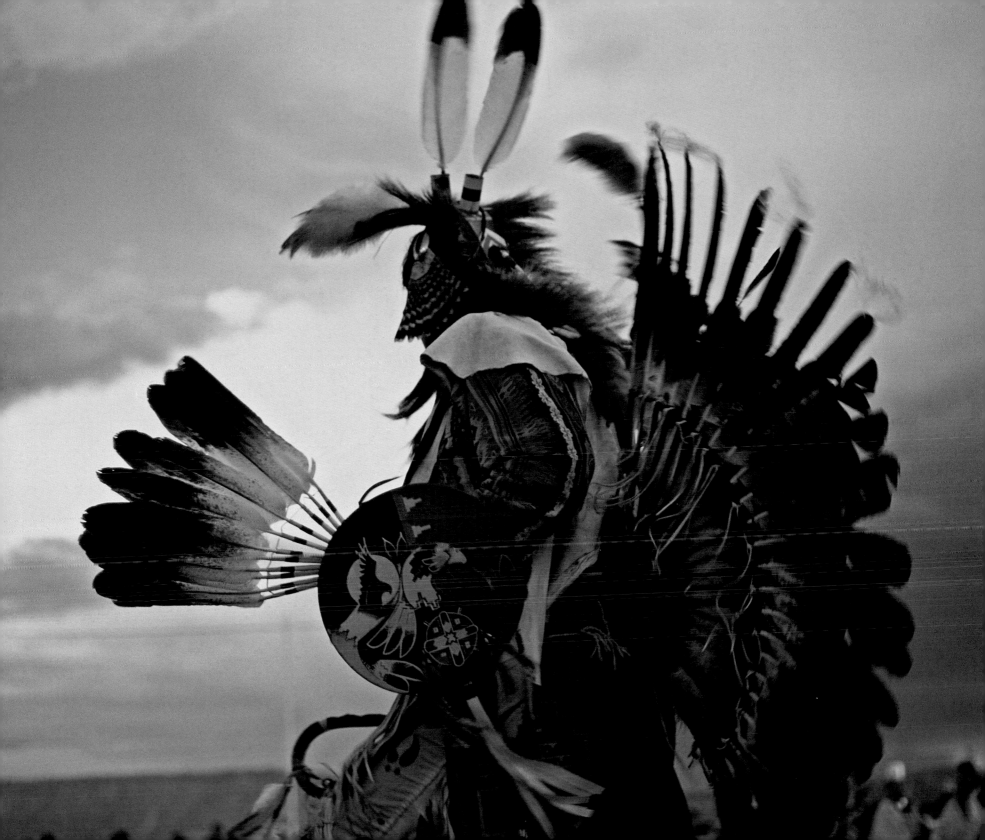

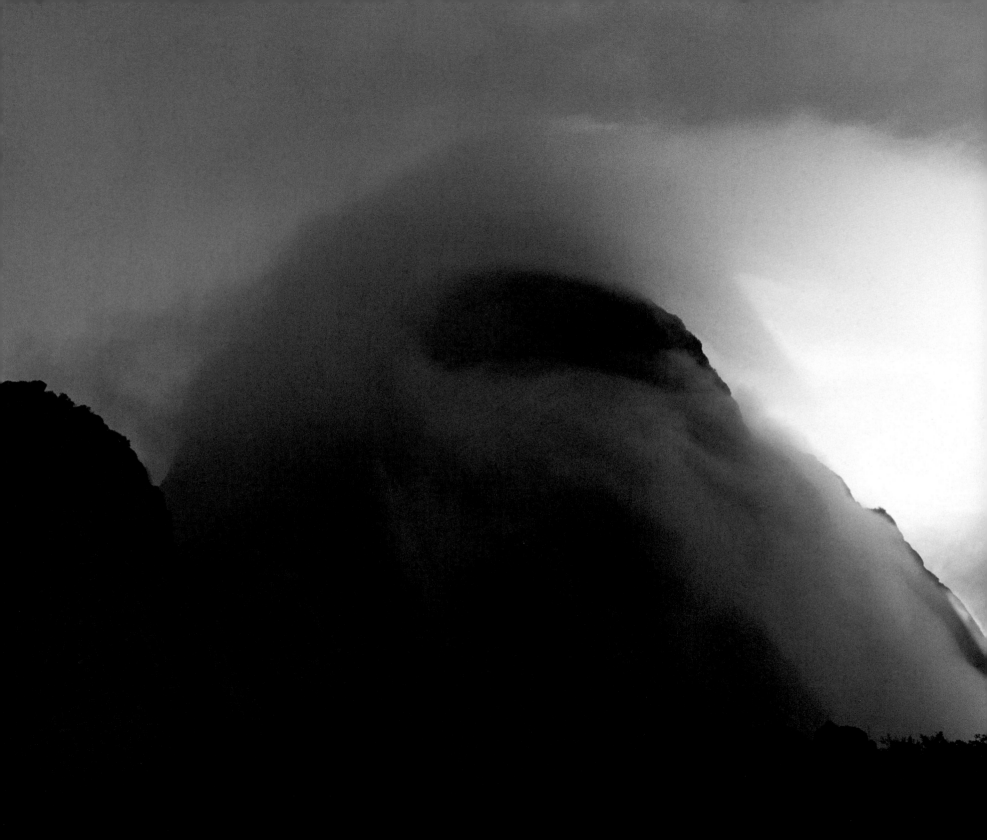

PAPAGUERÍA

In the Land of the Ó'odham *and* Comcáac, Pápago *and* Seri

D E S E R T S A N D T H E S E A

Our oral history . . . speaks of our relationship to

the earth, water, plants, animals and the universe.

Through the years, our ancestors placed prayers and offerings

in the mountains and Sacred Places so that we could survive . . .

— L O R R A I N E E I L E R, *Hia Ced Ó'odham*

I AM SLEEPING AT THE FOOT OF A ROCK THAT BLOTS OUT THE SUN. IT'S
taller then the Sphinx, it rivals the temples of Mayan gods, and it's as holy as Mount Horeb.
Not many people know this—or believe it, of course—except the Tohono Ó'odham, the
"Desert People." As far back as any living elder can remember, the Ó'odham have lived
within sight of Arizona's 7,734-foot Baboquivari Mountain. A storied pyramid of naked
granite one hundred stories high crowns a mountain range that cleaves the earth thirty miles
north to south. Water from summer monsoons and winter rains nurtures sacred plants that
grow in emerald forests of saguaro, mesquite, palo verde, ironwood, and all manner of
thorny and succulent cacti. They bristle from magnificent *bajadas,* alluvial fans that sweep
down from craggy ridgetops across endless desert valleys that are home to animals like
the coyote, roadrunner, tortoise, gila monster, rattlesnake, and cactus wren, which also come
to life in oral histories and song. Baboquivari is the heart of the Ó'odham's universe. Formed

PREVIOUS PAGE: *Baboquivari Mountains, Arizona. Baboquivari is the sacred mountain of the Tohono Ó'odham, the dwelling place of their creator,* Íitoi, *"Elder Brother."*

OPPOSITE: *Sunburst petroglyph, Tohono Ó'odham lands, Arizona. The spirit realm of mythic ancestors called the* Hohokam *bears many dialects of an ancient sign language lost to modern knowledge.*

by cataclysmic forces long before the Desert People first notched their legends in wooden calendar sticks, it is the home of *Íitoi,* "Elder Brother," the Ó'odham's creator.

Songbirds flit from evergreen oaks and stir me from my slumber. I peer out from my sleeping bag and blink my eyes. I do not believe what I see. A wispy plume of morning clouds enshrouds the black peak in a halo of white light, backlit by the rising sun. I stand up in my cocoon and fill my lungs with the cool mountain air. It's a moment of reckoning for me, the day I came to understand what the Ó'odham had been saying: Baboquivari is sacred ground.

A half-century earlier, William O. Douglas described the scene that now held me in its thrall. "It was a mountain wholly detached from the earth," he wrote, "a magic pillar of granite riding high above dark and angry clouds. Lightning briefly played around its base; and then it vanished as quickly as it appeared." That's where my journey to explore *Papaguería* began: at the foot of the sacred mountain the Ó'odham call *Vavkívolik,* "Mountain Narrow in the Middle."

Hot, sweet coffee puts a spring in my step as my partner and I climb through misty clouds up a steep ramp that winds up the same magic pillar of granite that Supreme Court Justice Douglas had climbed one tempestuous day long ago. His words were poetry to my ears. But it was the cryptic report from a 1898 edition of *The Yuma Sun* that first lured me to the abode of *Íitoi:* "Papago Indian legend has it that many years ago some red men of that tribe scaled the precipitous mountain while pursued by the Spaniards." Once we started following their ancient route from the desert floor to the summit, I was convinced that the Ó'odham, (formerly called Pápago) made pilgrimages to *Íitoi* to place prayers and offerings in his mountain home.

The Ó'odham had made such journeys before. Their fleet-footed ancestors once journeyed on foot from the village of *Kóksumök,* "Burnt Dog," all the way to the Sea of Cortez, where they collected salt during ritual pilgrimages to sing for power at the edge of the ocean: "Although the south seemed very far," they sang, "Clear to the edge of it did they go."

From the summit of *Vavkívolik,* I could see the four horizons of the Ó'odham's world seemed very far, indeed—but I was determined to go to the edge of it. I traveled north to the lands of their cousins, the *Ákimel Ó'odham,* "River People," to climb *Kakatat Tamai,*

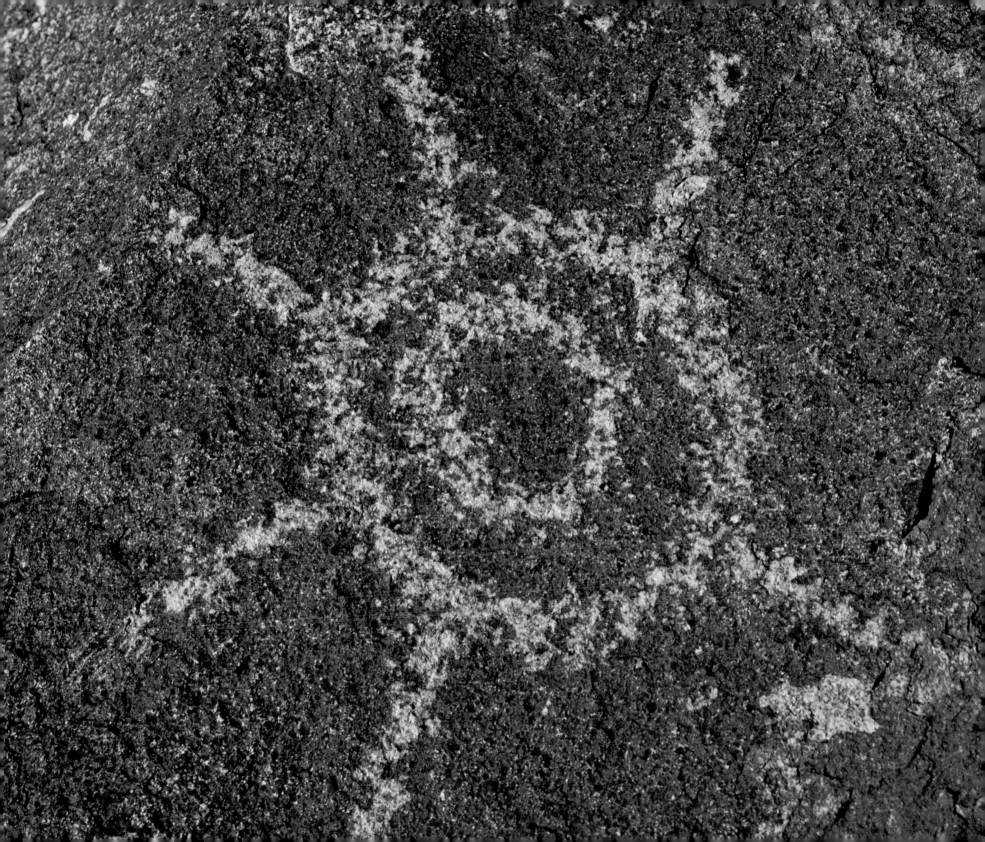

"Crooked Top Mountain." From the 5,057-foot summit of their most sacred mountain, I could see a hundred miles due south across *Papaguería* to Baboquivari, the dwelling place of *Íitoi*. I traveled east to the foothills of *Tjukson* "Foot of the Black Hill," where the Tohono Ó'odham collected fruit from the sacred *ha:sañ,* "saguaro cactus." They sprouted from the sweat of their creator *Íitoi* and provided the Ó'odham with nectar during times of drought, elixir for the annual *naváita,* "wine-drinking ceremony," and wooden ribs for building shelters. From these distant saguaro camps, I could also see the dwelling place of *Íitoi*. I traveled south into Mexico, where Spanish missionary explorer Padre Francisco Eusebio Kino first saw the castellated mountain on February 13, 1699. From the vicinity of the padre's camp, I could also see the dwelling place of *Íitoi*. I traveled west from Tucson across *Papaguería,* where Norwegian explorer Carl Lumholtz first studied the people who called it home. From many points along his wagon route, I could also see the dwelling place of *Íitoi*. I traveled in many other directions to see ancient hieroglyphics that still marked the realm of Ó'odham's mythic ancestors the *Hohokam,* "Those Who Are Gone." Black and brown stones still bore their ancient sign language, dreams of shamans who journeyed through the spirit world, and sacred trail maps that marked secret paths to life-giving water. From each of these stone tablets, I could also see the dwelling place of *Íitoi*.

I climbed Baboquivari again, and when I looked out in the four directions I had traveled, blue mountains floated in the desert sea. In his poetic account of his Baboquivari climb, William O. Douglas also wrote, "To the south and west the great expanse of the Sonoran Desert lay at my feet. It seemed empty, without life." On subsequent journeys I discovered firsthand that it was not a land without life. It was a living desert for Pápago ranchers like Ed Kisto, who ran cattle before he died on a spread that always had Baboquivari in view. It was a playground for schoolgirls who carried on the ancient tradition of playing *tóka,* "double ball," in a desert that also had Baboquivari in view. And it was an altar for medicine men who blessed sacred places that still have Baboquivari in view.

Pápago rancher Ed Kisto, Baboquivari Valley, Arizona. Following the traditions of Indian "cowboys" who once herded livestock for Spanish missionaries, the late Ed Kisto ran cattle at the foot of Baboquivari Peak (OPPOSITE), *called* Vavkívolik, *"Mountain Narrow about the Middle."*

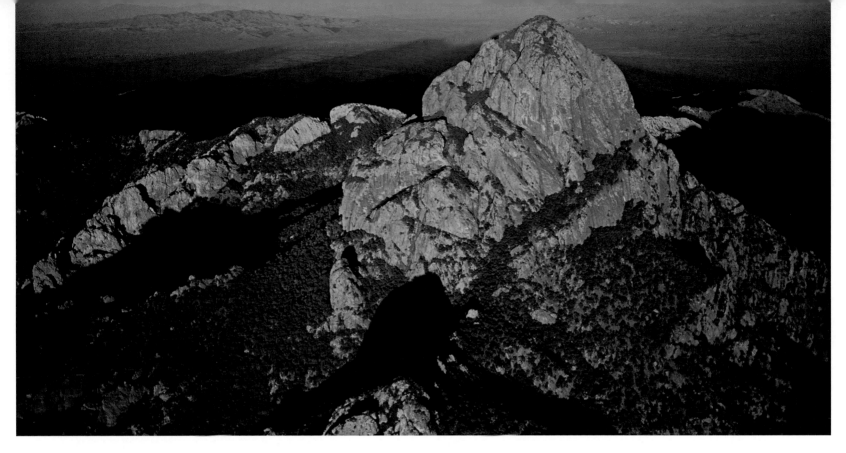

It was only when I ventured over the horizon line, beyond the curve of the earth that I thought I could sometimes see from the summit of Baboquivari, that the dwelling place of *Íitoi* fell from view but not from my memory.

It fell from view when I explored *Tahéöjc,* "Tiburon Island," the Seri's ancestral home of the *Comcáac,* "The People," far to the south.

It fell from view when I visited the late Francisco "Chico" Shunie, the last of the desert-dwelling Sand Pápago who lived far to the west.

And it fell from view—but not from my memory—the day I ventured into a sea of sand in the desert heartland of the Sand Pápago, who once lived even farther west. Known today as the *Hia Ced Ó'odham,* "Sand People," they roamed the driest, most forbidding desert in North America and eked out a hardscrabble living in the haunting lava and sand that Forty-Niners cursed God had forgotten. When Padre Kino camped at the waterhole— *Óovak,* "Where Arrows Were Shot"—in 1699, he wrote, "Here Manje counted thirty naked and poverty stricken Indians who lived solely on roots, lizards, and other wild foods."

OPPOSITE: *Water Hole petroglyph,
Tohono Ó'odham lands, Arizona.
Ancestral* Hohokam *may have drawn
and chiseled an abstract map of their
trails and water holes.*

Bedouins of the Sonoran Desert, the *Hia Ced Ó'odham* had a distinctly different view of themselves: "We are all Sand Indians. We are not known as on top of the sand. We are from the sand, and known as Sand Indians, to find our way of life on the sand of the earth." I walked into their world, on the burned fringes of the lush desert that the Tohono Ó'odham called home, to glimpse life that their ancestors endured for a thousand years before they vanished from the sands.

It's late morning on a sunny winter day when a friend drops me off on the south end of the middle of nowhere. I put one foot in front of the other and key off a peak that the *Hia Ced Ó'odham* called *Kusvo To:b Do'ag,* "Twisted-Neck Mountain." It marks the approximate location of my truck on the north end of a mirage called the Mohawk Sand Dunes. I slog up a barren ridge of sand, dwarfed by the serrated teeth of the Mohawk Mountains to the east and the austere sweep of the Mohawk Desert to the west. The *Hia Ced Ó'odham* once journeyed on foot for days on end along ancient trails that crossed the grim June desert from *Kusvo To:b Do'ag* to slake their thirst at *Tjunikáak,* "Where There Is Sahuaro Fruit." But I see nothing of their passage, just sand. The *Hohokam* also crossed this void for days from the Salt and Gila River Valley to collect shells in the Sea of Cortez. But I see nothing of their passage, either, just sand.

I follow the ridgeline along the crest of the dunes. Pockmarked with ankle-wrenching kangaroo rat holes, it leads through creosote, sand verbena, desert lily, primrose, big galleta grass, and white bursage. This was said to be the domain of coyotes, kit foxes, jackrabbits, bobcats, nighthawks, sidewinders, and fringe-toed lizards. But I see nothing of their passage, either, except more sand—grains, ripples, drifts, hummocks, dunes, and blowouts of aeolian sand.

Here there is nothing but sand, sun, and silence. There is no living water in these sands or stone rain catchments called *tinajas,* only ephemeral playas that hold the promise of water for a few days if and when it rains. It almost never does. When the *Hia Ced Ó'odham* crossed El Gran Desierto, the great sand sea to the south, the food and moisture from the *hía tatk,* "sand root," sustained them. I see nothing of these mysterious life-saving sand roots, either. But I glance down and notice two large pieces of pottery glimmering in the sand. I stoop down, and brush the sand off the broken edges and smooth brown curves.

The shards are thicker to touch than the eggshell-thin clay pots the Seri once used to carry water across their desert to the south, but my guess is they are pieces of water vessels that were once carried between distant sand camps and *tinajas*. Here was proof the *Hohokam* and *Hia Ced Ó'odham* had crossed the sand. So I decide to make camp.

The sun falls behind the purple veil of the Gila Mountains. I take off my pack and unshoulder two one-gallon plastic water jugs. The shards have survived the elements here for hundreds of years. My own canteens, if left unattended, would last two to three weeks before the sun burned them brittle. I put the shards back where I found them. They will soon be buried by the same wind that carried these sands all the way from the Sea of Cortez. I gather a pile of dead twigs and branches and build a small cook fire. I put three corn-husked tamales on the embers and then stare at the night sky.

A brilliant moon peers over the crest of the Mohawk Mountains and ignites the sand with luminous white light. In the moon and firelight, I see the shadows of the Sand Indians walking through this white mirage. They are following the words of Owl Woman, who sings them into the spirit land: "In the great night my heart will go out / Toward me the darkness comes rattling / In the great night my heart will go out."

In this great night my heart goes out—and longs to know still more about the people who vanished from these sands.

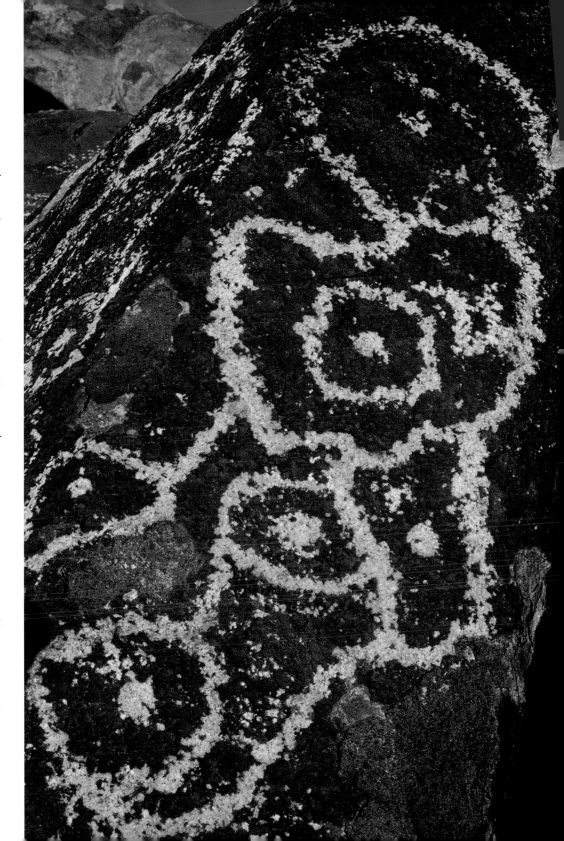

OPPOSITE: *Stickball players, San Simon, Arizona. Wielding sticks bent and fire-hardened from cat's claw, schoolgirls carry on the ancient Ó'odham tradition of playing* tóka, *"double ball,"* (LEFT) *in the seared reaches of the Sonoran Desert.*

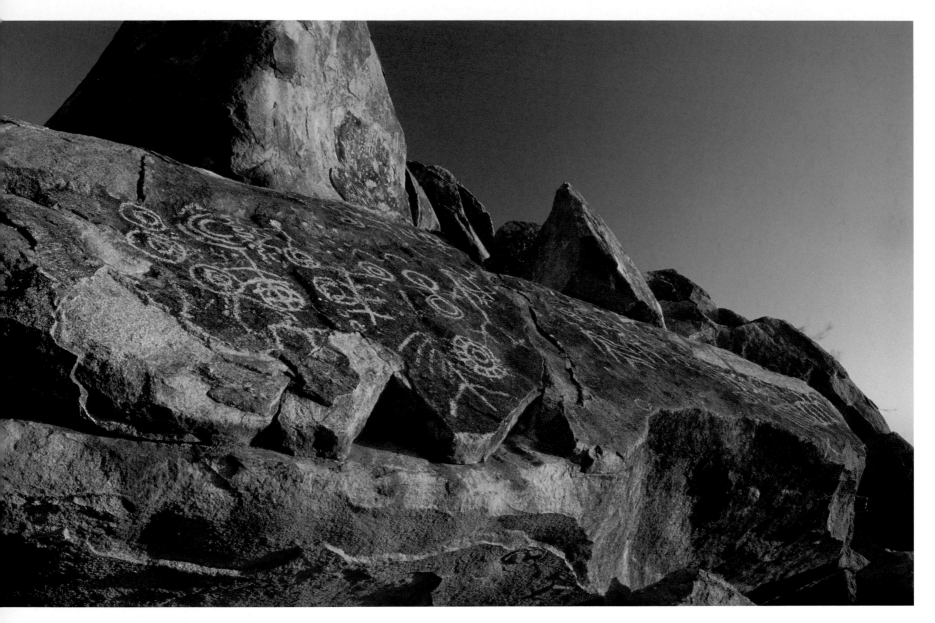

*Sleeping circles petroglyph, Sonoran Desert, Arizona. During their quest for fire, food, and water,
the* Hohokam *utilized stone sleeping circles* (OPPOSITE) *as windbreaks and may have etched camp
impressions that represent sleeping circles they once used in Arizona's Lechuguilla Desert.*

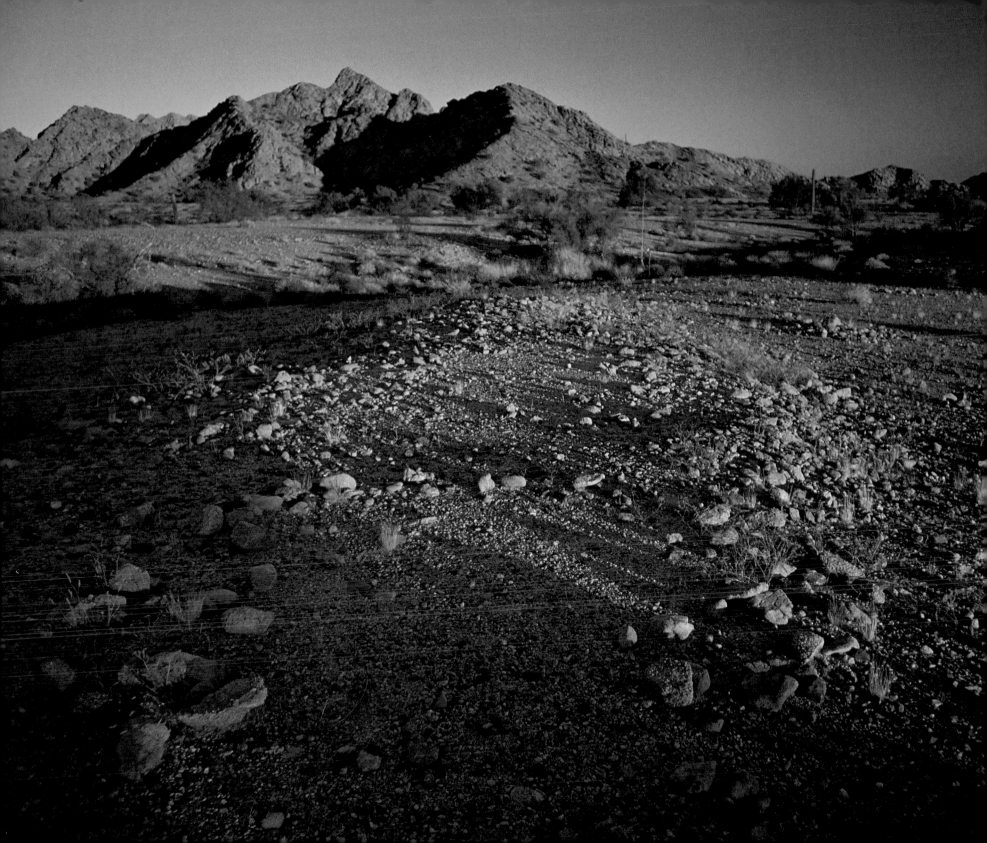

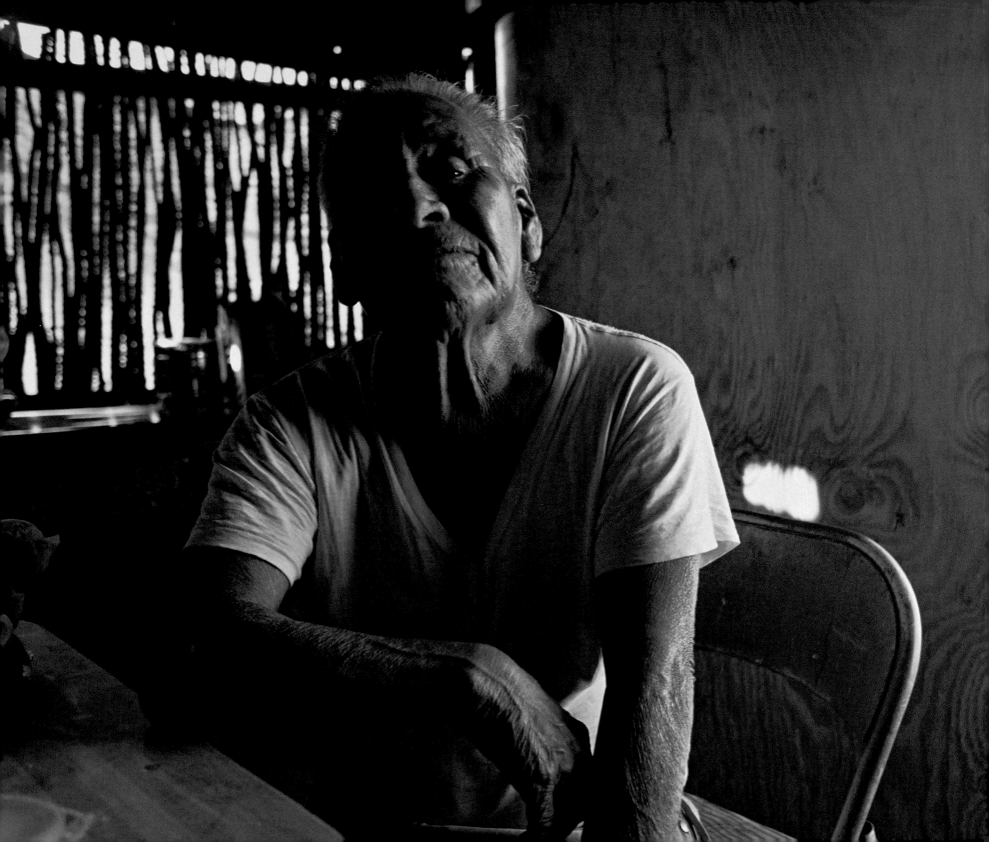

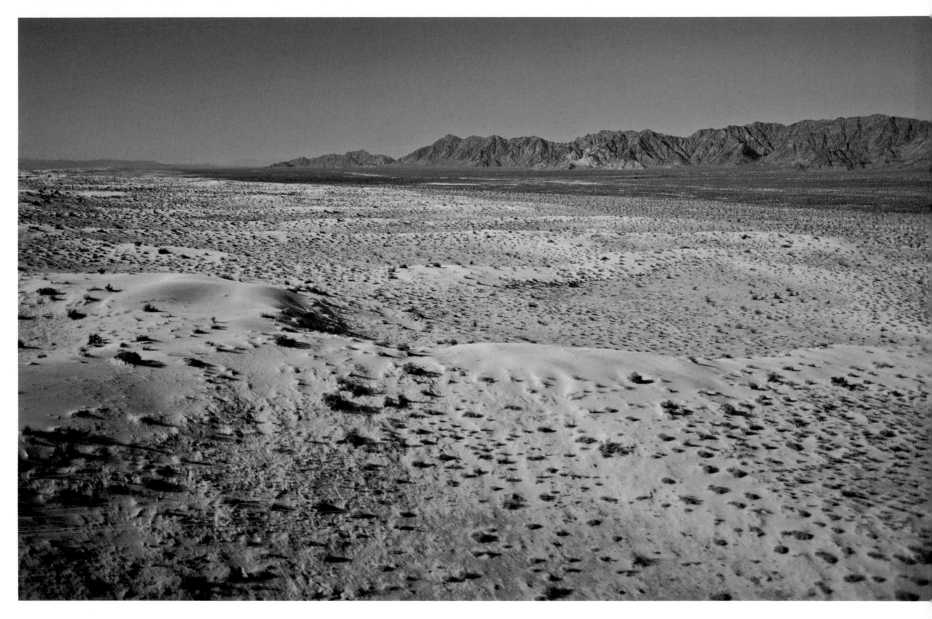

OPPOSITE: *The last of his tribe, Chico Shunie Well, Arizona. The late Francisco "Chico" Shunie was the last of the desert-dwelling Sand Pápago who roamed the harshest tracts of the Sonoran Desert* (ABOVE), *including southwestern Arizona's Mohawk Sand Dunes.*

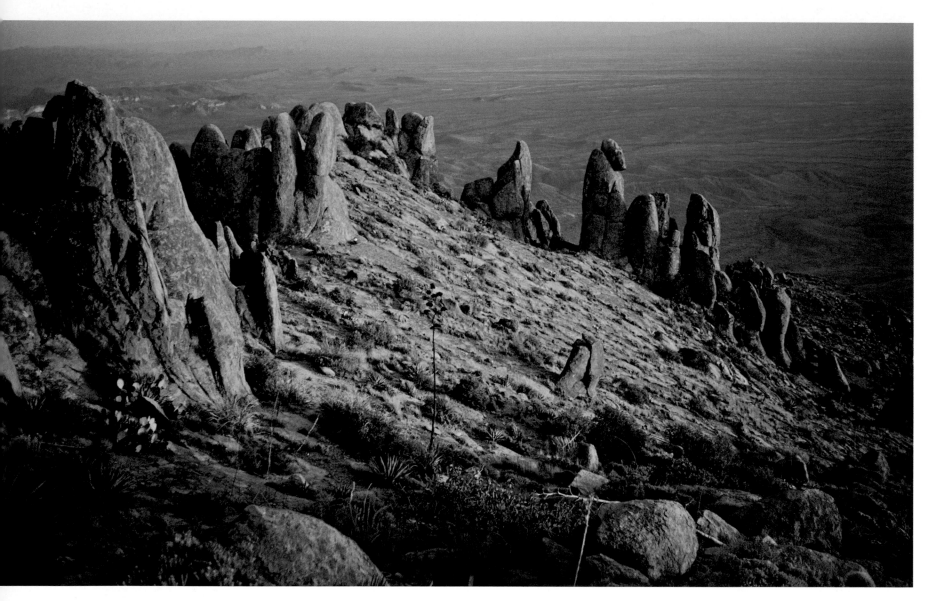

Superstition Mountain, Arizona. From the summit of Kakatat Tamai, *"Crooked Top Mountain," the sacred mountain of the* Ákímel Ó'odham, *the ancestral land of the Ó'odham stretches hundreds of miles south across the Sonoran Desert to the Sea of Cortez* (OPPOSITE), *where the Tohono Ó'odham once journeyed for salt during ritual pilgrimages.*

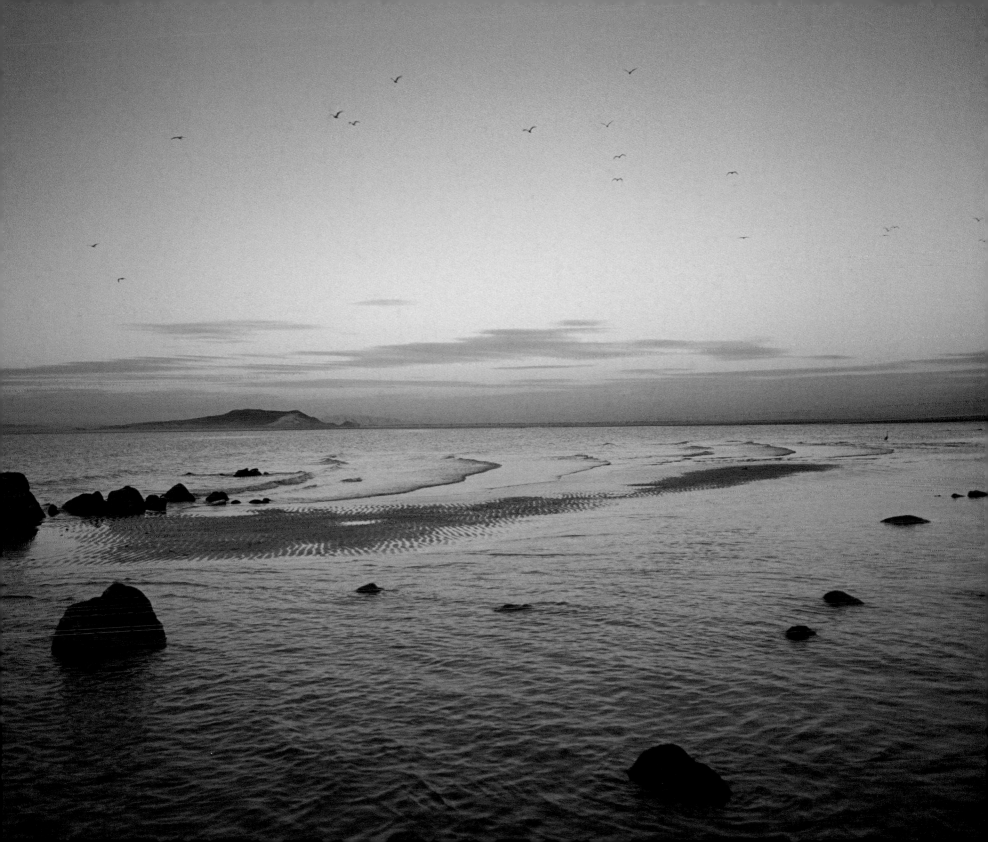

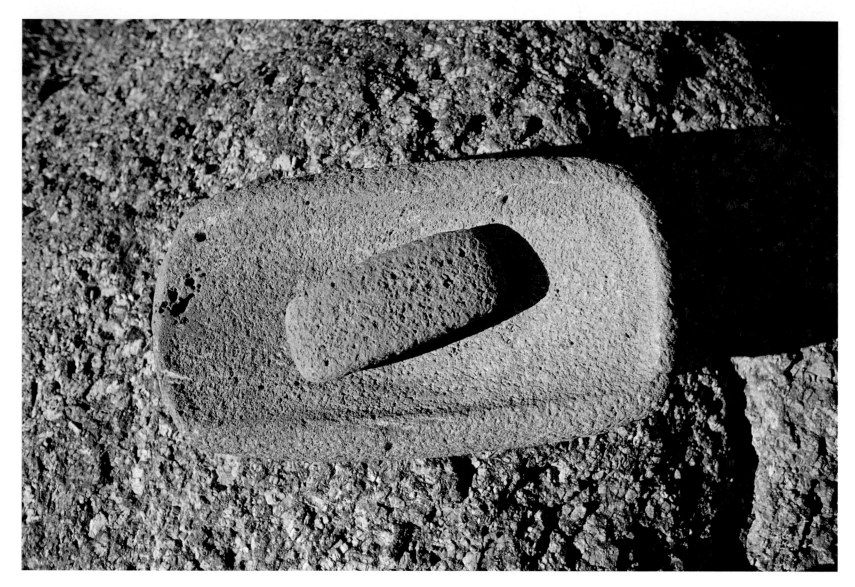

ABOVE: *Metate, Sonoran Desert, Arizona. Held by the hands of ancient* Hohokam, *this metate was used to grind corn, mesquite beans, and seeds for food.*

OPPOSITE: Hohokam *visions, Sonoran Desert, Arizona. These remarkable hieroglyphics may depict either shamans' visions or the journeys of ancient pilgrims who crossed the desert to collect salt from the Sea of Cortez.*

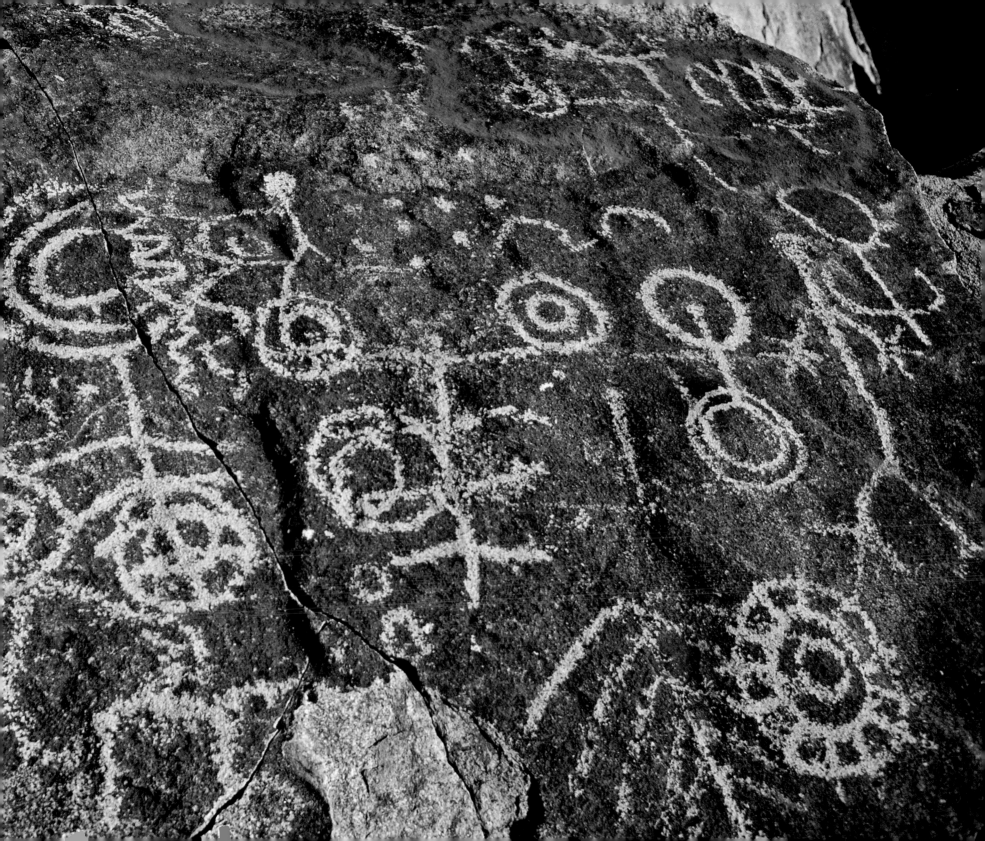

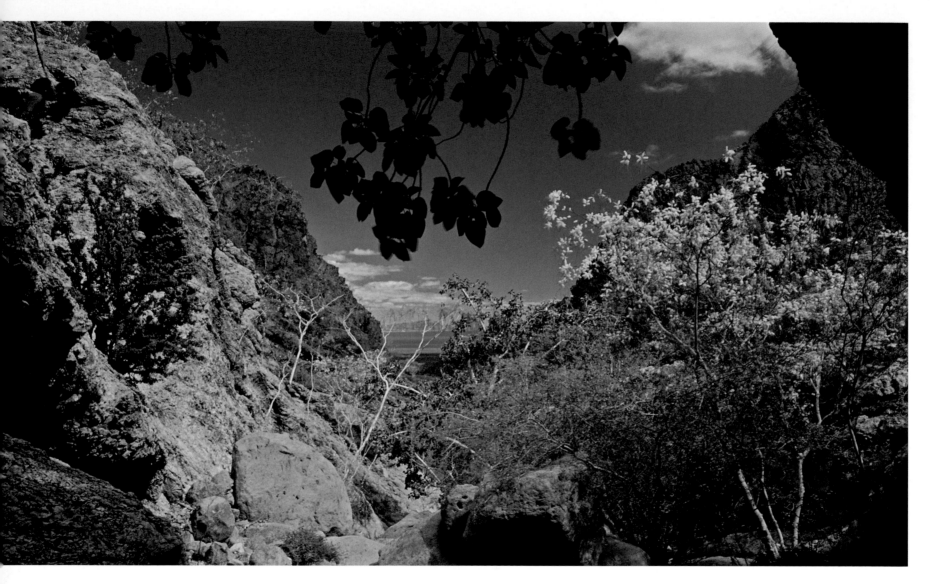

Seri Spirit World, Tiburon Island, Sea of Cortez. Ancestral home of the Comcáac, *the spirit world of the Seri is located in* Tahéöjc Imozit, *"the Heart of Tiburon."*

OPPOSITE: *Saguaro cactus, Sonoran Desert, Arizona. Sacred to the Tohono Ó'odham, the* has:sañ, *"saguaro cactus," is said to have sprouted from the sweat of their creator,* Íitoi, *"Elder Brother."*

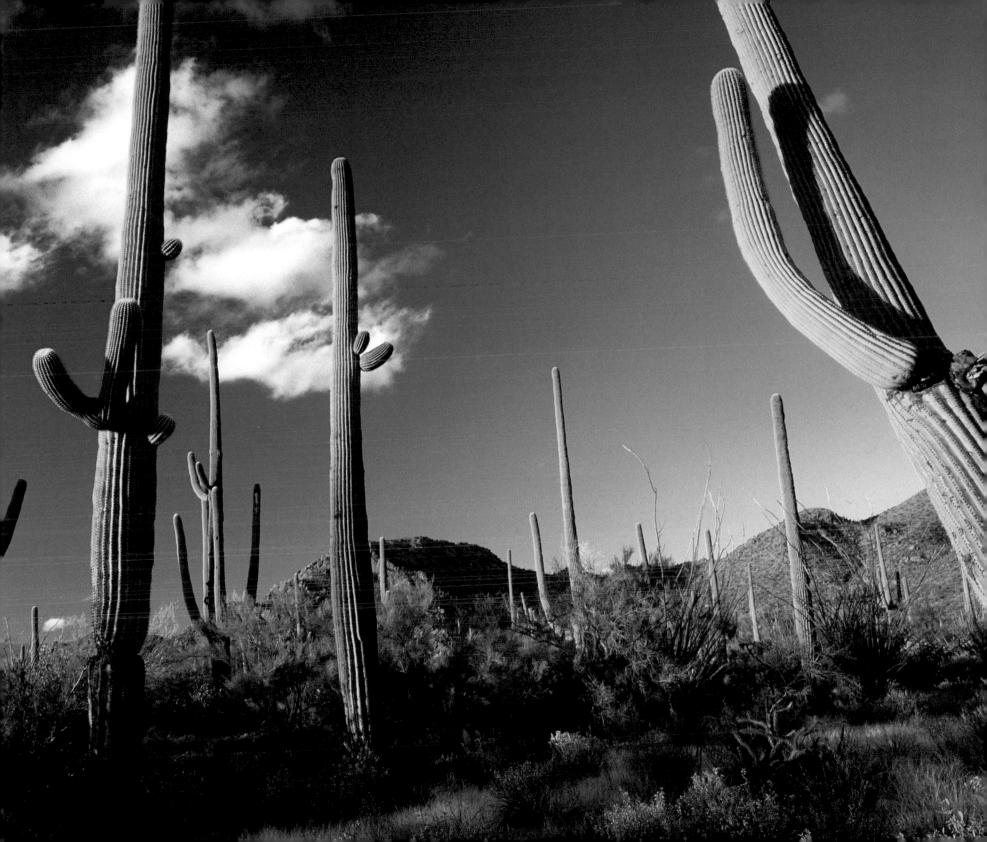

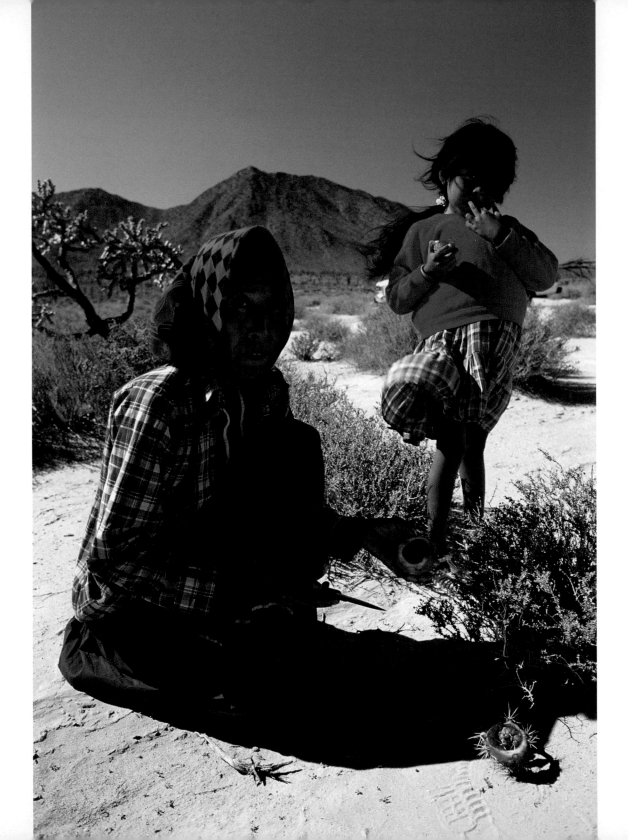

Pitaya gathering, Sonoran Desert, Mexico. Angelita Torres displays the tart red fruit of pitaya agria that the Comcáac harvest during the imán imán izax, *"moon of the ripe fruit," each June.*

OPPOSITE: *Seri basket weaver, Desemboque, Sonora, Mexico. Rosa Barnett uses a deer bone awl to weave a large ceremonial basket called a* sapim. *A "dangerous spirit" known as* Coen *sometimes wailed when the awl screeched through the basket coils and was appeased by weavers who tossed cactus fruit on the ground near the basket.*

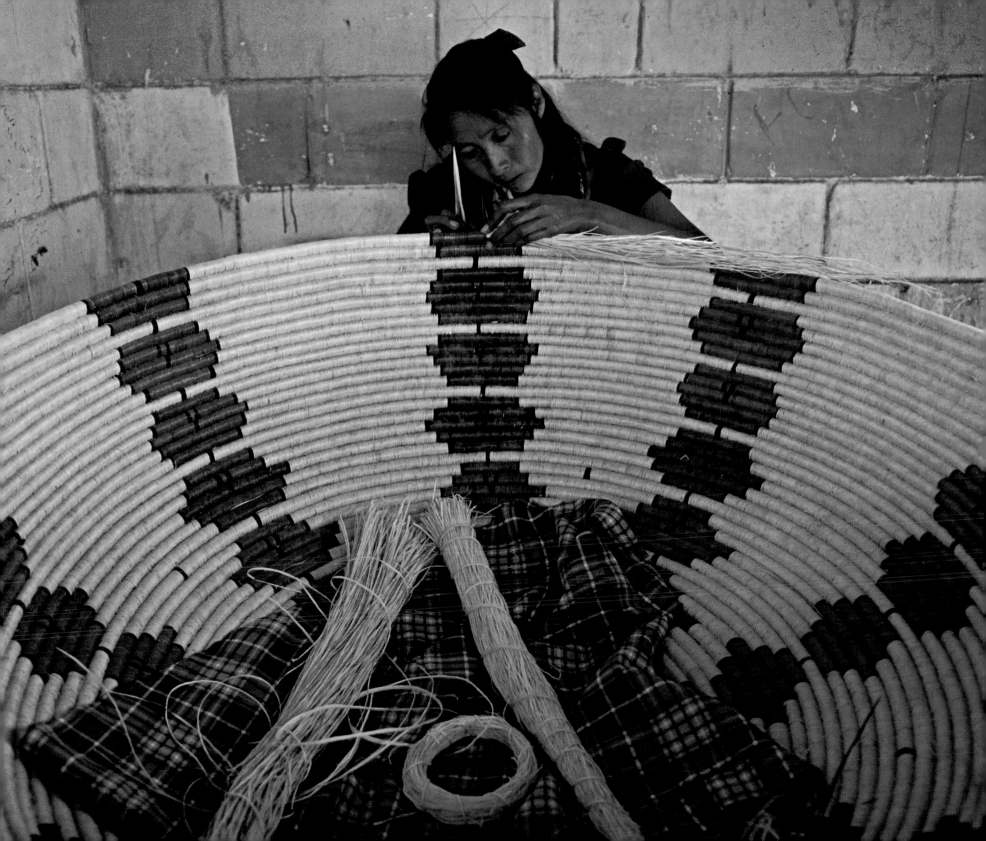

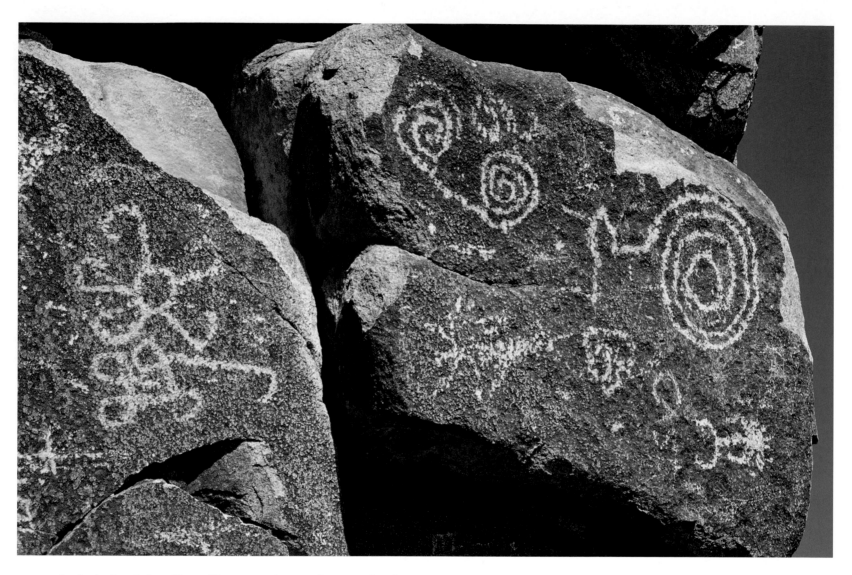

ABOVE: *Snake den inscriptions, Tucson Mountains, Arizona. Some speculate that concentric circles symbolize journeys and migrations; others suggest that they represent serpents, which explains the Diamondback rattlesnake that startled me below this panel.*

OPPOSITE: *Stone tablets, Tohono O'odham lands, Arizona. An open book to an ancient world, these stone tablets are inscribed with a perplexing message that few can discern with certainty.*

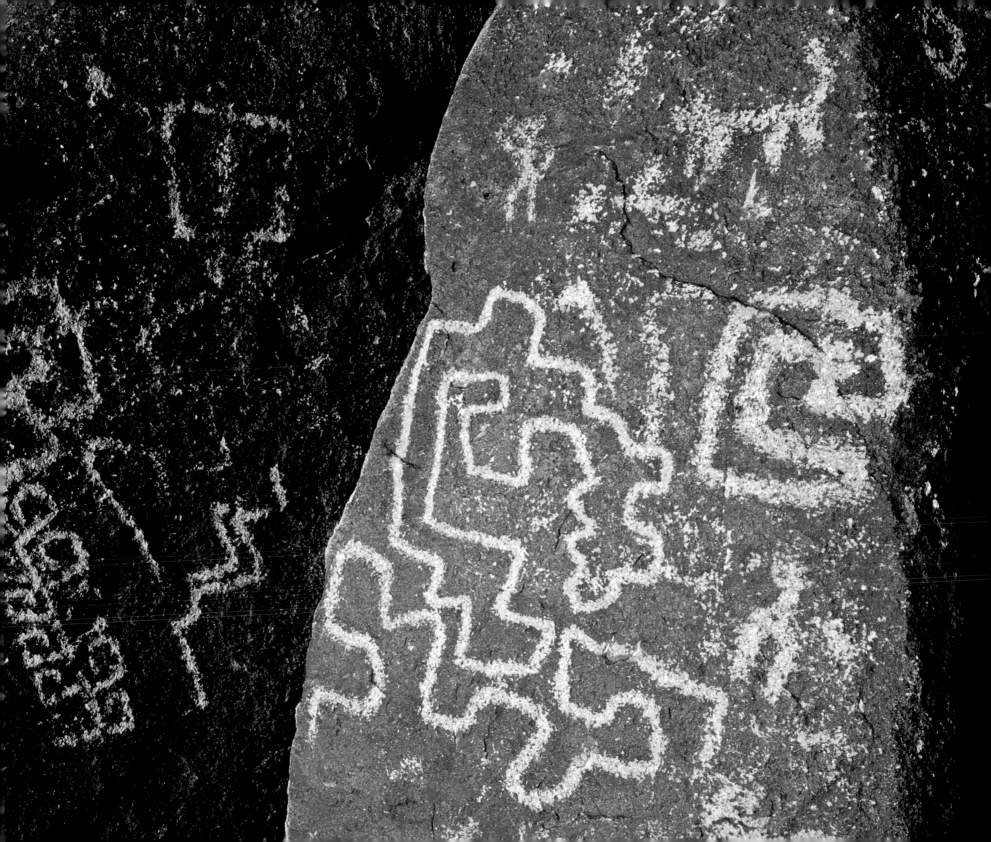

Ocotillo, Growler Valley, Arizona. Tracing ancient trails across the desert to harvest nectar at Tjunikáak, *"Where There is Sahuaro Fruit," the* Hia Ced Ó'odham *also used the spiny arms of the ocotillo for building shelters.*

OPPOSITE: *Shamans, Sonoran Desert, Arizona. By moon- and firelight, medicine man and woman Melvin and Katherine Deer bless an ancestral* Hohokam *burial site desecrated by a developer's backhoe on* Ákímel Ó'odham *sacred ground.*

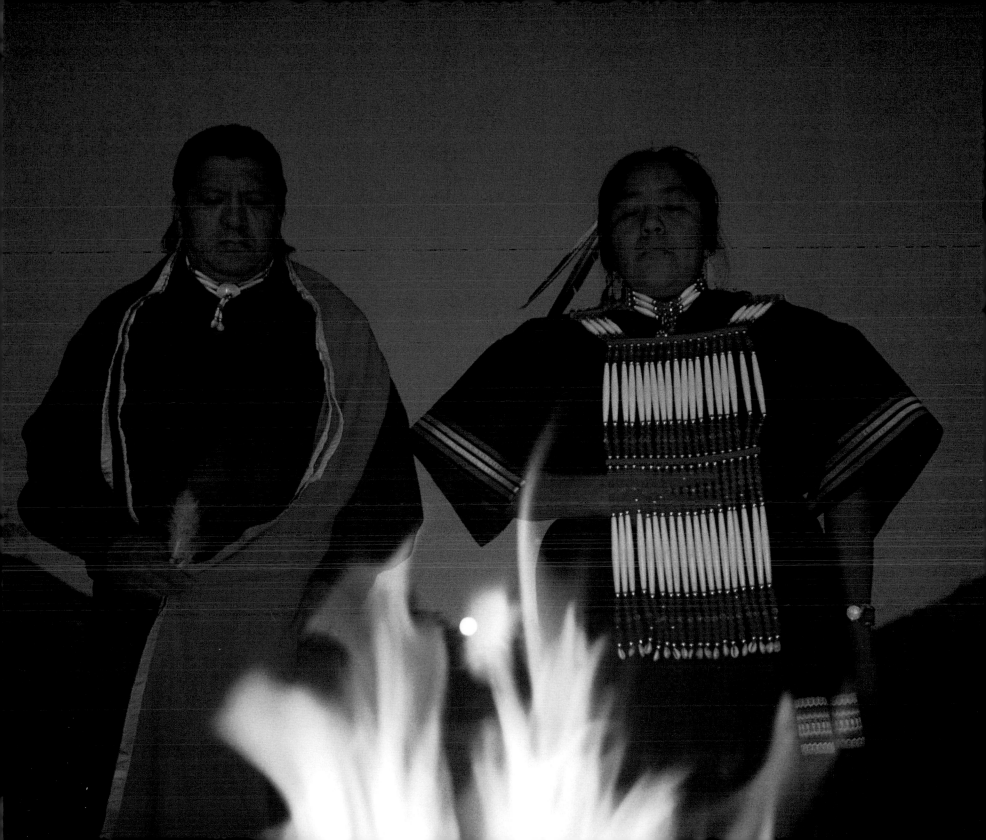

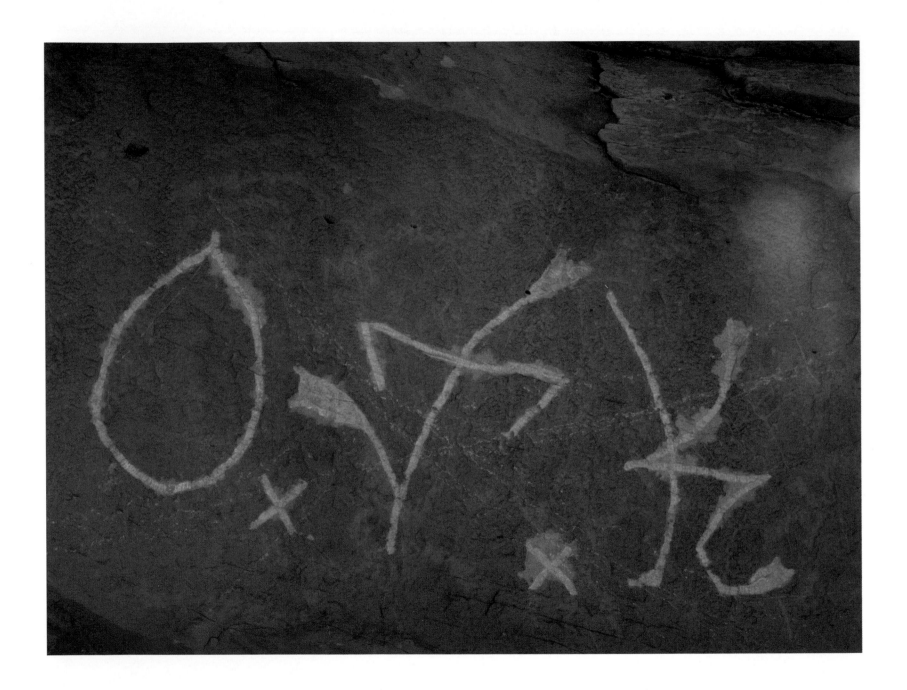

FRAGILE LEGACY

Tutuventiwngwu, "Place of the Clan Rocks," (page 78) is one of the most venerable shrines in Native America. Dating back to perhaps A.D. 1250, it holds the spiritual legacy for living descendants of Hopi men who inscribed their sacred clan symbols during perilous pilgrimages through the Little Colorado River Gorge to pay homage at *Sipápuni,* "Place of Emergence," en route to collect salt in the Grand Canyon, called by the Hopi *Öwngtupka,* "Salt Canyon."

The Antiquities Act of 1906, Archaeological Resources and Protection Act of 1979, and Native American Graves Protection and Repatriation Act of 1990 were enacted to protect Native American religious shrines, burial grounds, ancient dwellings, and sacred areas like *Tutuventiwngwu.*

They did not.

Years after tracing the Hopi's route down the length of the Little Colorado River Gorge on foot from Cameron, Arizona to the Grand Canyon, I finally visited *Tutuventiwngwu.* I was looking forward to a few quiet moments to contemplate hallowed stones that had been etched by ancient hands, but I was blindsided by the spray paint, graffiti, and vandalism that defiled *Tutuventiwngwu.* It had not escaped the rampant desecration of sacred sites throughout Native America's ancestral lands, including America's national parks and public lands.

My spirit sank when I saw this modern gang sign gouged into the heart of Indian Country's most sacred ground.

Was nothing sacred anymore?

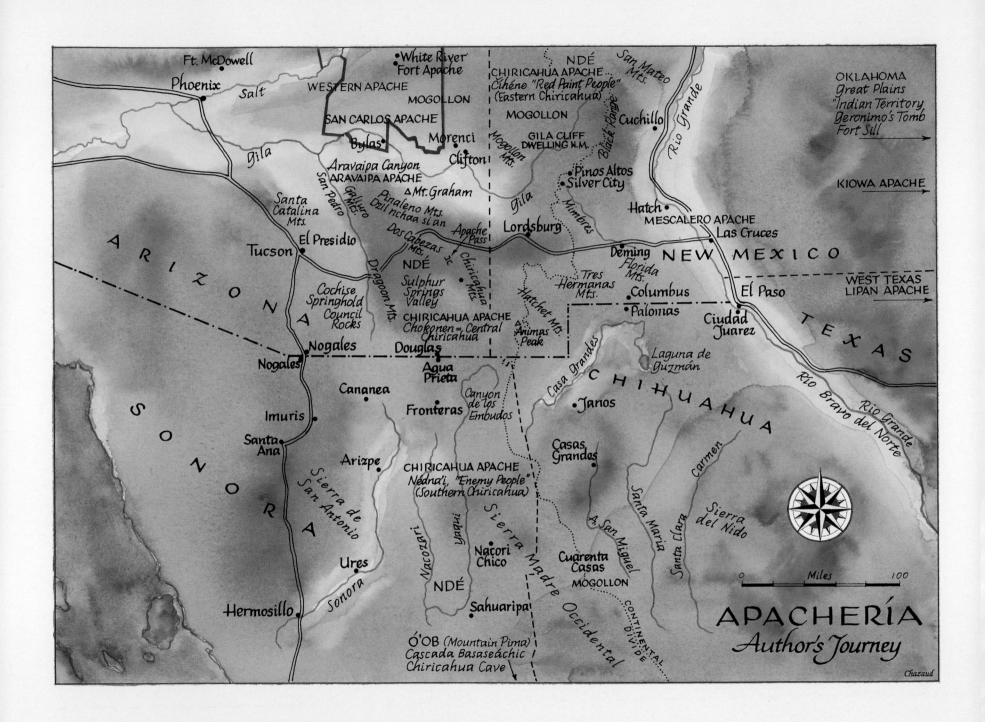

Ft. McDowell

White River
Fort Apache

NDÉ
CHIRICAHUA APACHE...
Cíhéne "Red Paint People"
(Eastern Chiricahua)

San Mateo
Mts.

OKLAHOMA
Great Plains
"Indian Territory,
Geronimo's Tomb
Fort Sill →

Phoenix

Salt

WESTERN APACHE

MOGOLLON

SAN CARLOS APACHE

Bylas

Morenci

Clifton

Aravaipa Canyon
ARAVAIPA APACHE

△ Mt. Graham

Pinaleno Mts.
Dził nchaa si an

Santa
Catalina
Mts.

San Pedro

Galiuro Mts.

Dos Cabezas
Mts.

Apache
Pass

El Presidio

Tucson

Dragoon Mts.

NDÉ

Sulphur
Springs
Valley

Chiricahua Mts.

Cochise
Springhold
Council
Rocks

CHIRICAHUA APACHE
Chokonen = Central
Chiricahua

Nogales

Nogales

Douglas

Agua
Prieta

Cananea

Fronteras

Canyon
de los
Embudos

Imuris

Santa
Ana

Arizpe

Sierra
de
San Antonio

Nacozari

Yaqui

CHIRICAHUA APACHE
Nédna'i, "Enemy People"
(Southern Chiricahua)

Sierra Madre Occidental

Nacori
Chico

NDÉ

Ures

Hermosillo

Sonora

Sahuaripa

Ó'OB (Mountain Pima)
Cascada Basaseáchic
Chiricahua Cave

MOGOLLON

Cuchillo

Gila Cliff
DWELLING N.M.

Black Range

Rio Grande

KIOWA APACHE →

Mogollon Mts.

Pinos Altos
Silver City

Gila

Lordsburg

Mimbres

Hatch

MESCALERO APACHE

Las Cruces

Deming

NEW MEXICO

Florida
Mts.

Tres
Hermanas
Mts.

Columbus

Palomas

Hatchet Mts.

Animas
Peak

Ciudad
Juarez

El Paso

WEST TEXAS
LIPAN APACHE →

TEXAS

Casa Grandes

Laguna de
Guzmán

CHIHUAHUA

Janos

Rio Grande

Rio Bravo del Norte

Casas
Grandes

Carmen

Santa Clara

Sierra
del Nido

A. San Miguel

Santa Maria

Cuarenta
Casas

MOGOLLON

CONTINENTAL DIVIDE

0 Miles 100

APACHERÍA
Author's Journey

Chazaud

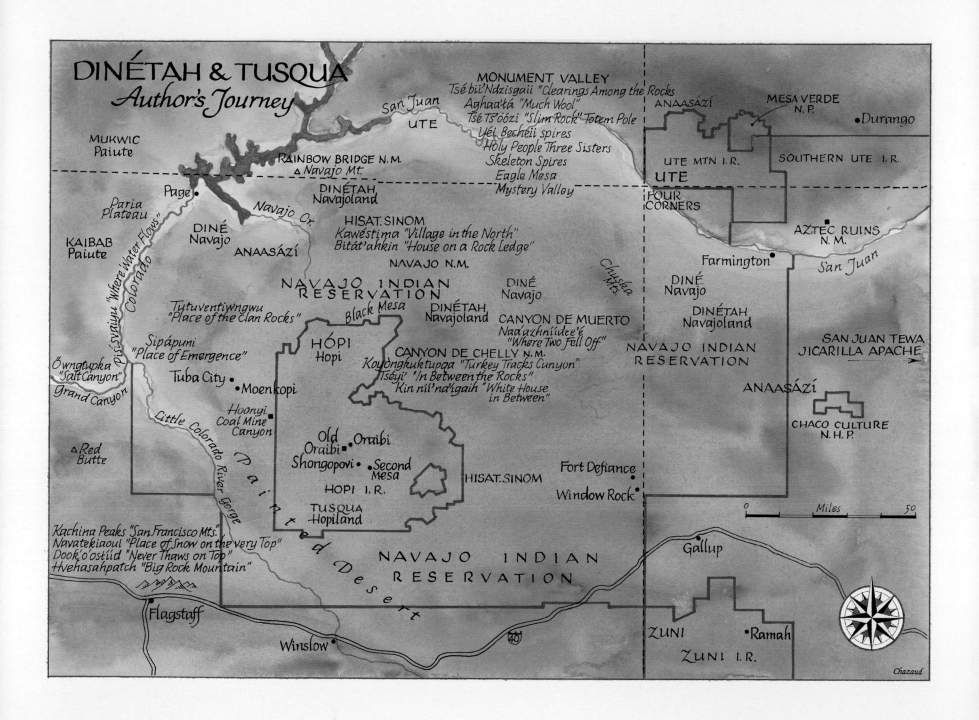

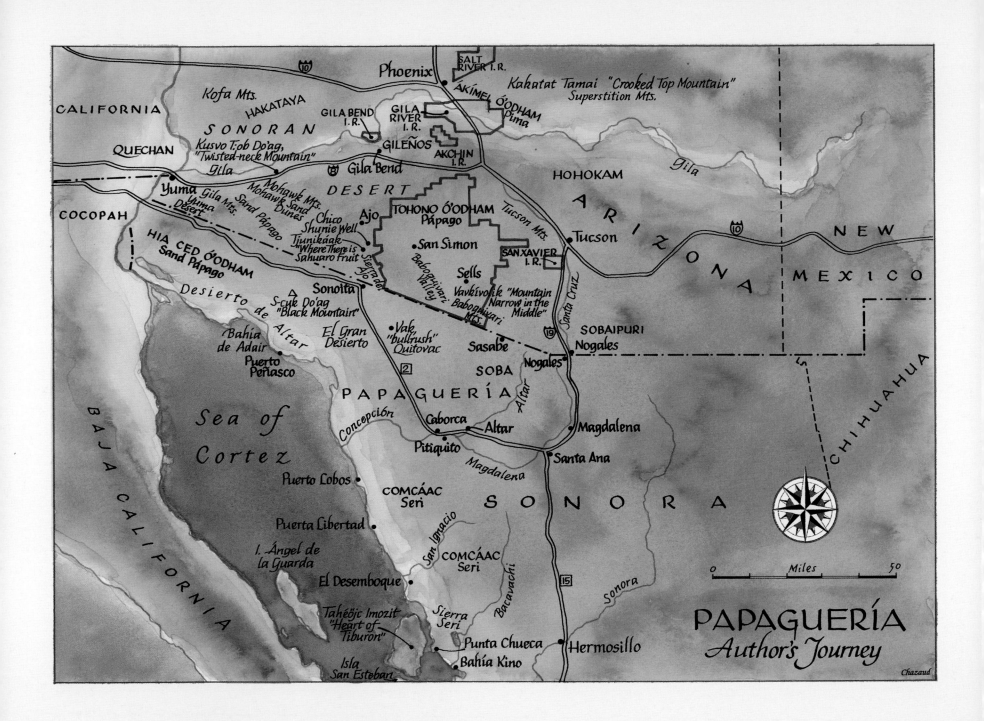

PAPAGUERÍA
Author's Journey

Chazaud

SELECTED BIBLIOGRAPHY

Annerino, John. *Desert Light: A Photographer's Journey through America's Desert Southwest,* (photographs by the author). Woodstock, VT: Countryman Press, 2006.

____. *Canyon Country: A Photographic Journey* (photographs by the author). Woodstock, VT: Countryman Press, 2005.

____. *Apache: The Sacred Path to Womanhood* (photographs by the author). New York: Marlowe & Company, 1999.

____. *Running Wild: An Extraordinary Adventure of the Human Spirit* (photographs by Christine Keith). New York: Thunder's Mouth Press, 1998.

____. "People of the Sierra: Mountain Pima/O'ob" (photographs by the author), *Native Peoples Magazine,* vol. 10, no. 4 (Summer 1997): 48–53.

____. *People of Legend: Native Americans of the Southwest* (photographs by the author). San Francisco: Sierra Club Books, 1996.

____. "Powwow: Dancing to the Distant Drums" (photographs by the author). *Perspective, The Arizona Republic* (September 17, 1995): F–1&2.

____. "Warriors of Healing: Indian Veterans Find Strength in Traditional Mysticism" (photographs by the author). *Perspective, The Arizona Republic* (January 1, 1995): F–1&2.

____. "The Cowboy Way: Indian Style" (photographs by the author). *Perspective, The Arizona Republic* (October 16, 1994): E–1&2.

____. "The Last of His Tribe" (photograph by the author). *Perspective, The Arizona Republic* (August 21, 1994): E–1&3 [Chico Shunie].

____. *Adventuring in Arizona* (photographs by the author). San Francisco: Sierra Club Books, 1991; 2nd ed.1996; 3rd ed. by University of Arizona Press, 2003.

____. "People of the Dune: The Seri Indians" (photographs by the author). *Northern Arizona Life,* vol. 2, no. 3 (May 1985): cover, 24–32.

____. "Four Sacred Mountains" (photographs by the author). *The Navajo Times,* vol. 24, no. 32 (August 12, 1982): 14.

Associated Press, "Saving the Sacred Lands and Monuments." *Indian Country Today* (July 26, 200): C–7.

Baum, Dan. "Sacred Places: Five Hundred Years After Columbus, More Than Sixty Native American Spiritual Sites Across the Country Face Their Greatest Threat Ever." *Mother Jones,* vol. 17, no.2 (March–April 1992): 32–38, 75.

Basso, Keith H. "The Gift of Changing Woman." *Anthropological Papers,* no.76, Bureau of American Ethnology Bulletin, 196: 115–173. Washington, DC: U.S. Government Printing Office, 1966.

____. "Western Apache." *Handbook of North American Indians: Southwest,* vol. 10. Washington, DC: Smithsonian Institution, 1983: 462–488.

Bernbaum, Edwin. *Sacred Mountains of the World.* San Francisco: Sierra Club Books, 1990.

Boardman, Peter. *Sacred Summits: A Climber's Year.* London: Hodder and Stoughton, 1982.

Broyles, Bill, et al. "Our Grand Desert: A Gazetteer for Northwestern Sonora, Southwestern Arizona, and Northeastern Baja California." *Dry Borders: Great Natural Reserves of the Sonoran Desert.* Salt Lake City: University of Utah Press, 2006: 581–679.

Brugge, David M. "History, Huki, and Warfare: Some Random Data on the Lower Pima." *The Kiva,* vol. 26, no. 4 (April 1961): 6–16.

Colton, Harold S. (clan symbols interpreted by Hopi Edmund Nequatewa). "Fools Names Like Fools Faces." *Plateau,* vol. 19, no. 1 (July 1916): 1–8.

Colton, Harold S., and Mary Russell F. "Petroglyphs: The Record of a Great Adventure." *American Anthropologist,* vol. 33, no. 1 (January–March 1931): 32–37.

Curtis, Edward S. *The North American Indian: Being a Series of Volumes Picturing and Describing the Indians of the United States and Alaska.* Cambridge, MA: University Press, 1907–1930.

D'Azevedo, Warren L., ed. *Handbook of North American Indians: Great Basin,* vol. 11. Washington, DC: Smithsonian Institution, 1986.

Debo, Angie. *Geronimo: The Man, His Time, His Place.* Norman: University of Oklahoma Press, 1978.

Densmore, Francis. *Papago Music.* Bulletin 90. Washington, DC: Bureau of American Ethnology, 1929.

Douglas, William O. "Baboquivari" (drawings by Ted DeGrazia). *Arizona Highways,* vol. 27, no. 4 (April 1951):16–21.

Eiler, Lorraine, chairwoman. "Hia-Ced Ó'odham Statement to the Regional Town Hall Meeting Ajo, Arizona, October 23, 1992": 1–4.

Felger, Richard S., and Mary Beck Moser. *People of the Desert and the Sea: The Ethnobotany of the Seri Indians.* Tucson: University of Arizona Press, 1985.

Felger, Richard S., et al. "Botanical Diversity of Southwestern Arizona and Northwestern Sonora." *Dry Borders: Great Natural Reserves of the Sonoran Desert.* Salt Lake City: University of Utah Press, 2006: 202–271.

Fewkes, J. Walter. "The Snake Ceremonies at Walpi." *Journal of American Ethnology and Archaeology,* vol. 4. Cambridge, MA: Riverside Press, 1894.

Fontana, Bernard L. "Pima and Papago: Introduction." *Handbook of North American Indians: Southwest,* vol. 10. Washington, DC: Smithsonian Institution, 1983: 125–136.

Forbes, Jack D. *Religious Freedom and the Protection of Native American Places of Worship and Cemeteries.* Davis: University of California Press, 1988.

Geronimo. *Geronimo: His Own Story, as Told to S. M. Barrett* (Introduction and Notes by Frederick Turner, ed.). New York: Meridian Books, 1996.

Gill, Sam D. "Navajo Views of Their Origin." *Handbook of North American Indians: Southwest,* vol. 10. Washington, DC: Smithsonian Institution, 1983: 502–505.

Granger, Byrd H. *Will C. Barnes' Arizona Place Names* (illustrated by Anne Merriam Peck). Tucson: University of Arizona Press, 1979.

Hackenberg, Robert A. "Pima and Papago Ecological Adaptions." *Handbook of North American Indians: Southwest,* vol. 10. Washington, DC: Smithsonian Institution, 1983; 161–177.

Henderson, Junius, and John P. Harrington. "Ethnozoology of the Tewa Indians." Smithsonian Institution, *Bureau of American Ethnology,* bulletin 56. Washington, DC: Government Printing Office, 1914.

Jett, Stephen C. "Testimony of the Sacredness of Rainbow Natural Bridge to Puebloans, Navajos, and Paiutes. *Plateau,* vol. 45, no. 4 (Spring 1973): 133–142.

Kelly, Isabel T. "Southern Paiute Ethnography." *Anthropological Papers,* no. 69 (May 1964), Glen Canyon Series no. 21. Salt Lake City: University of Utah, 1964.

Kenny, Brian W. "An Annotated Bibliography of Southwestern and Native American Religious Shrines, Rock Cairns, Stacked Rock Features, and Rock Markers." SASIG, (SWA Web site). January 1, 1996.

Kidder, Alfred Vincent, and Samuel J. Guernsey. *Archaeological Explorations in Northeastern Arizona,* Smithsonian Institution Bureau of American Ethnology, bulletin 65. Washington, DC: U.S. Government Printing Office, 1919.

Klah, Hasteen. *Navajo Creation Myth: The Story of Emergence* (recorded by Mary C. Wheelwright). Navajo Religion Series, vol. 1. Santa Fe: Museum of Ceremonial Art, 1942.

Linford, Laurance D. *Navajo Places: History, Legend, Landscape.* Salt Lake City: University of Utah Press, 2000.

Lockwood, Frank C. *The Apache Indians.* New York: Macmillan, 1938.

Luckert, Karl W. *Navajo Mountain and Rainbow Bridge Religion.* Flagstaff: Museum of Northern Arizona, 1977.

Lumholtz, Carl. *New Trails in Mexico: An Account of One Year's Explorations in North-Western Sonora, Mexico, and South-Western Arizona 1909–1910.* New York: Charles Scribner's Sons, 1912.

Matthiessen, Peter. *Indian Country.* New York: Penguin, 1974.

McLuhan, T. C., ed. *Touch the Earth: A Self Portrait of Indian Existence.* New York: Promontory Press, 1971.

McPherson, Robert S. *Sacred Land, Sacred View: Navajo Perceptions of the Four Corner Region.* Salt Lake City: Brigham Young University, Charles Redd Center of Western Studies, 1992.

Miles, Dale Curtis, and Paul R. Machula. *History of the San Carlos Apache.* San Carlos, AZ: San Carlos Apache Historic and Cultural Preservation Office, 1997.

Moser, Mary Beck, and Stephen A. Marlett. *Seri Spanish–English Dictionary (Comcáac quih yaza quih hant ihip hac).* Hermosillo, Estado de Sonora, Secreteria de Educación y Cultura: Universidad de Sonora; México, DF: Plaza y Valdes, 2006.

Nabhan, Gary Paul, et al. "A Meager Living on Lava and Sand? Hia Ced O'odham Food Resources and Habitat Diversity in Oral and Documentary Histories." *Journal of the Southwest,* vol. 31, no. 4 (Winter 1989): 508–533.

National Park Service, *Canyon de Chelly,* Canyon de Chelly National Monument, Arizona. U.S. Department of the Interior, 2005.

Norgay, Jamling Tenzing, with Broughton Coburn. *Touching My Father's Soul: A Sherpa's Journey to the Top of Everest* (foreword by His Holiness the Dalai Lama). San Francisco: Harper San Francisco, 2001.

Opler, Morris E. "Chiricahua Apache." *Handbook of North American Indians: Southwest,* vol. 10. Washington, DC: Smithsonian Institution, 1983: 401–418.

Ortiz, Alfonso, ed. *Handbook of North American Indians: Southwest,* vol. 10. Washington, DC: Smithsonian Institution, 1983.

_____. *Handbook of North American Indians: Southwest,* vol. 9. Washington, DC: Smithsonian Institution, 1979.

Page, Susanne and Jake. *Hopi* (photographs by Susanne Page). New York: Harry N. Abrams, 1982.

Plog, Fred. "Prehistory: Western Anasazi." *Handbook of North American Indians: Southwest,* vol. 9. Washington, DC: Smithsonian Institution, 1979: 108–130.

Reichard, Gladys A. *Navaho Religion: A Study in Symbolism.* Princeton, NJ: Princeton University Press, 1950.

Schaafsma, Polly. *Indian Rock Art of the Southwest.* Albuquerque: University of New Mexico Press, 1992.

Sekaquaptewa, Emory, Cultural Editor, and Kenneth C. Hill, Project Director, et al. *Hopi Dictionary, Hopìikwa Lavaytutuveni: A Hopi-English Dictionary of the Third Mesa Dialect.* Compiled by the Hopi Dictionary Project. Bureau of Applied Research and Anthropology. University of Arizona. Tucson: University of Arizona Press, 1998.

Spicer, Edward H. *Cycles of Conquest: The Impact of Spain, Mexico, and the United States on the Indians of the Southwest, 1533–1960.* Tucson: University of Arizona Press, 1962.

Sweeney, Edwin R. *Cochise: Chiricahua Apache Chief.* Norman: University of Oklahoma Press, 1991.

Talayesva, Don C. *Sun Chief: The Autobiography of a Hopi Indian* (Leo W. Simmons, ed.). New Haven, CT: Yale University Press, 1942.

"Territorialities," *The Yuma Sun,* July 29, 1898.

Titiev, Mischa. "A Hopi Salt Expedition." *American Anthropologist,* vol. 39, no. 2 (April-June 1937): 244–258.

Underhill, Ruth. *Papago Indian Religion.* New York: AMS Press, 1969.

Underhill, Ruth, et al. *Rainhouse and Ocean: Speeches for the Papago Year.* American Tribal Religions, vol. 4. Flagstaff: Museum of Northern Arizona Press, 1979.

Van Valkenburgh, Richard F., and Lucy Wilcox Adams and John McPhee, eds. *Diné Bikéyah* (The Navaho's Country). Window Rock, AZ: U.S. Department of the Interior, Office of Indian Affairs, Navajo Service, 1941.

Van Valkenburgh, Richard F., and Scotty Begay. "Sacred Places and Shrines of the Navajo, Part I, The Sacred Mountains." *Museum Notes,* Museum of Northern Arizona, vol. 11, no. 3 (September 1938): 29–34.

Van Valkenburgh, Richard F., and Clyde Kluckhorn, ed. "Navajo Sacred Places," Docket 229 (Navajo) Plaintiff's Exhibit No. 687, in *Navajo Indians III.* New York: Garland Publishing, 1974.

Van Valkenburgh, Richard F., and Frank O. Walker. "Old Place Names in Navajo Country," *Master Key,* vol. XIX, no. 3 (1945): 89–94.

Waters, Frank. *Book of the Hopi* (drawings and source material recorded by Oswald White Bear Fredericks). New York: Penguin, 1963.

Watson, Editha L. *Navajo Sacred Places.* Window Rock, AZ: Navajoland Publications, Navajo Tribal Museum, 1964.

Woodhead, Henry, ed., et al. *People of the Desert.* Alexandria, VA: Time-Life Books, 1993.

___. *The Spirit World.* Alexandria, VA: Time-Life Books, 1993.

Young, Robert W. "Apachean Languages." *Handbook of North American Indians: Southwest,* vol. 10. Washington, DC: Smithsonian Institution, 1983: 393-400.

Young, Robert W., and William Morgan. *The Navaho Language.* United States Department of the Interior, Office of Indian Affairs. Phoenix: Phoenix Indian School, 1943.

LITERATURE CITED

p. 5. "The ground on which we stand is sacred ground." Chief Plenty-Coups in T. C. McLuhan, *Touch the Earth: A Self-Portrait of Indian Existence.* New York: Promontory Press, 1971, p.136.

p. 11. "Stand alone on the summit of some sacred mountain," Editha L. Watson, *Navajo Sacred Places.* Window Rock, AZ: Navajoland Publications, Navajo Tribal Museum, 1964, p. 5.

p. 12. ". . . live with as closely as their own heart-beats." Watson, 1964, p. 5.

p. 13. "It was not astonishing for them that supernatural beings . . ." Watson, 1964, p. 5.

p. 23. "Cochise's survival skills were legendary." Edwin R. Sweeney, *Cochise: Chiricahua Apache Chief.* Norman: University of Oklahoma Press, 1991, p. xxii.

p. 28. ". . . rugged heights and deep gulches." Sweeney, 1991, p. 358.

p. 28. ". . . to Fort Bowie to notify all troops that a cease fire was in effect.'" Sweeney, 1991, p. 358.

p. 29. "Upon the death of Cochise, I found . . ." Thomas J. Jeffords in Sweeney, 1991, p. 396.

p. 29. "He was dressed in his best war garments . . ." Frank C. Lockwood, *The Apache Indians.* New York: Macmillan, 1938, pp. 129–130.

p. 47. "Each of these mountains has a story, prayer, song and ceremony . . ." Floyd Laughter in Karl W. Luckert, *Navajo Mountain and Rainbow Bridge Religion.* Flagstaff: Museum of Northern Arizona, 1977, p. 51.

p. 50. ". . . sacred power which should not be disturbed." Robert S. McPherson. *Sacred Land, Sacred View.* Salt Lake City: Brigham Young University, 1992, p. 99.

p. 50. ". . . spirits can attack a person and cause sickness." McPherson, 1992, p. 99.

p. 50. ". . . dwelling place of the gods . . ." Gladys A. Reichard. *Navaho Religion: A Study in Symbolism.* Princeton, NJ: Princeton University Press, 1950, pp. 81–82.

p. 52. "Birds . . . may symbolize the shamanic power of magic flight." Polly Schaafsma. *Indian Rock Art of the Southwest.* Albuquerque: University of New Mexico Press, 1992, p. 71.

p. 53. ". . . the spirit of a dead person goes after burial." McPherson, 1992, p. 29.

p. 89. "Our oral history . . . speaks of our relationship to . . ." Lorraine Eiler. "Hia Ced Ó'odham Statement to the Regional Townhall Meeting Ajo, Arizona, October 23, 1992," p. 1.

p. 90. "It was a mountain wholly detached from the earth a magic pillar of granite . . ." William O. Douglas. "Baboquivari," *Arizona Highways,* vol. 27, no. 4 (April 1951): p. 16.

p. 90. "Papago Indian legend has it that many years ago . . ." "Territorialities," *The Yuma Sun,* July 29, 1898, p. 1.

p. 90. "Although the south seemed very far . . ." Jose Moreno in Ruth Underhill, et al., *Rainhouse and Ocean: Speeches for the Papago Year.* American Tribal Religions, vol. 4. Flagstaff: Museum of Northern Arizona Press, 1979, p. 66.

p. 92. "To the south and west the great expanse of the Sonoran Desert . . ." Douglas, 1951, p. 18.

p. 93. "Here Manje counted thirty naked and poverty stricken Indians . . ." Juan Mateo Manje in John Annerino's *Adventuring in Arizona,* San Francisco: Sierra Club Books, 1991, p. 30.

p. 94. "We are all Sand Indians." Miguel Velasco in Gary Paul Nabhan, et al. "A Meager Living on Lava and Sand? Hia Ced O'odham Food Resources and Habitat Diversity in Oral and Documentary Histories." *Journal of the Southwest,* vol. 31, no 4 (Winter 1989): p. 521.

p. 95. "In the great night my heart will go out . . ." Owl Woman, Juana Manwell, in Francis Densmore *Papago Music,* Bulletin 90. Washington, DC: Bureau of American Ethnology, 1929, p. 127.

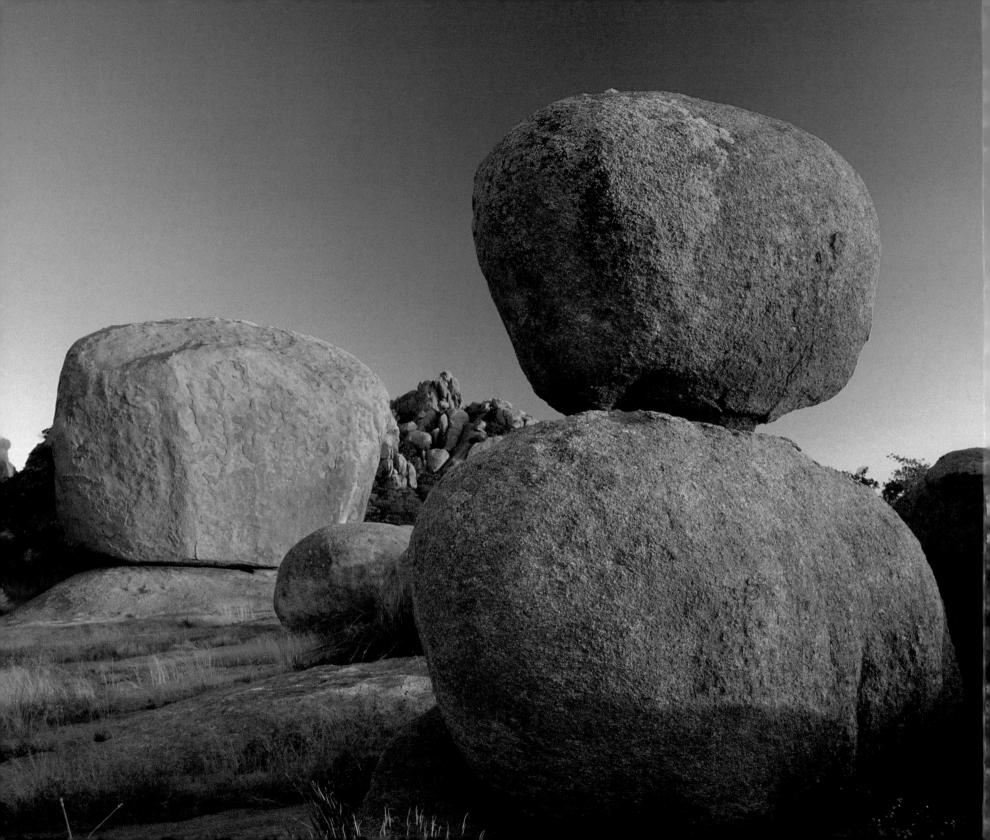

GLOSSARY

'Aghaa'łá, "Much Wool" (Agathla Peak, AZ), Navajo

Ákímel Ó'odham, "River People," Pima.

'Álá Tsoh, "Big Hands" (Mitten Buttes, Monument Valley, AZ), Navajo.

Al Waipa, "Little Wells" (Aravaipa Canyon, AZ), Pima

Apachería, "Land of the Apache," Spanish.

'apa'tó, "Lost Spring" (Willow Spring, AZ), Navajo

Anaasází, "Enemy Ancestors," Navajo.

Aski-Ei-Bah, "War Pony," Navajo.

Bitát'ahkin, "House on a Rock Ledge" (Betatakin, Navajo National Monument, AZ), Navajo.

Bi til tih, "Night Before Dance," Apache.

ch'íindii, "spirits," Navajo.

Chiricahua Apache, from *Chiguicagui,* "Mount of the Wild Turkeys," Ópata

Chokonen (Central Chiricahua), Apache.

Čihéne, "Red Paint People" (Eastern Chiricahua), Apache.

Ciko Su:ni, "Francisco "Chico" Shunie," Pápago

Coen, "dangerous spirit," Seri.

Council Rocks, West Stronghold. During the U. S. government's war against the Apache, Cochise made peace with General Oliver Howard at Council Rocks in 1872.

Comcáac, "The People," Seri.

Dibé nitsaa, "Big Mountain Sheep" (Hesperus Peak, La Plata Range, CO), Navajo.

Diné, "The People," Navajo.

Dinétah, "Navajoland," Navajo.

dí yin, "one who has power" (medicine man), Apache.

Dook'o'osłíid, "Never Thaws on Top" (San Francisco Mountains, AZ), Navajo.

Dootł'izhiidziil, "Turquoise Mountain" (Mount Taylor, San Mateo Mountains, NM), Navajo.

dzileezh bijish, "medicine pouches," Navajo.

Dził Nchaa Sián, "Big Seated Mountain" (Piñaleno Mountains, AZ), Apache.

Ga'an, "Mountain Spirits," Apache.

gową, "wickiup," Apache.

Haashch'eeh diné, "Holy People," Navajo.

ha'athali, "singers," Navajo.

has:sañ, "saguaro cactus," Pápago.

Hashké Neiinihí Biye', "Giving Out Anger" (Hoskinnini Begay), Navajo.

Hia Ced Ó'odham, "In-the-Sand People," Sand Pápago.

hía tatk, "sand root" (Pholisma sonorae), Sand Pápago.

Hisat.sinom, "People Who Lived Long Ago," Hopi.

Hohokam, "Those Who Are Gone," Pima.

Hoongi, "Standing Up" (Coal Mine Canyon, AZ), Hopi.

Honoo jí, "Sawtoothed" (Coal Mine Canyon, AZ), Navajo.

Hópi, "One Who Is Mannered," Hopi.

Hvehasahpatch, "Big Rock Mountain" (San Francisco Mountains, AZ), Havasupai.

Íitoi, "Elder Brother" (Creator), Pápago.

Ih Sta Nedleheh, "White Shell Woman" (Mother of the Apache), Apache.

imán imán izax, "moon of the ripe fruit" (pitaya harvest time), Seri.

Kachina, "Spirit of the Invisible Forces of Life," Hopi.

Katsina, "Spirit Being" (Kachina), Hopi.

Kakatat Tamai, "Crooked Top Mountain" (Superstition Mountain, AZ), Pima.

kanenă, "buffalo," San Juan Tewa.

Kastíila, "Spanish/Mexican," Hopi.

Kawéstima, "Village in the North" (Betatakin, Navajo National Monument, AZ) Hopi

Kin níí' na' igaih, "White House in Between" (White House Ruin, Canyon de Chelly National Monument, AZ), Navajo

Kókopilau, "Humpbacked Flute Player" (Kokopeli), Hopi.

Kókopnyam, "Fire Clan," Hopi.

Kóksumök, "Burnt Dog" (Topawa, AZ), Pápago.

Koyòngkuktupqa, "Turkey Tracks Canyon" (Canyon de Chelly, AZ), Hopi.

Kusvo To:b Do'ag, "Twisted Neck Mountain" (Mohawk Peak North, AZ), Sand Pápago.

Másaw, "Guardian of the Underworld,"Hopi.

metate, "grinding stone," Spanish.

Mukwic, "People We Never Saw," Paiute.

Naa'azhníídee'é, "Where Two Fell Off" (Massacre Cave, Canyon de Chelly National Monument, AZ), Navajo.

Nabááh jiłt'áá, "Warrior Grabbed Enemy" (Manuelito), Navajo.

na ih es, "getting her ready" (coming-of-age ceremony), Apache.

Navatekiaoui, "Place of Snow on the Very Top" (San Francisco Mountains, AZ), Hopi.

naváita, "wine drinking ceremony," Pápago.

Ndé, "Man" or "People," Apache.

Nédna'í, "Enemy People" (Southern Chiricahua), Apache.

Ne'éshjaa', "The Owl," Navajo.

Nílch'ijí, "Wind Chant," Navajo.

Nóódá'altii' Bił Yikahigi, "More Than Three Utes Which Ride Along on Horses" (Ute Fight Mural, Canyon del Muerto, Canyon de Chelly National Monument, AZ), Navajo.

Öngmokto, "go on a salt expedition," Hopi.

Ó'ob (Mountain Pima), Pima.

Ó'odham, "People," Pápago.

Óovak, "Where Arrows Were Shot" (Tinajas Altas, AZ), Pápago.

Öwngtupka, "Salt Canyon" (Grand Canyon, AZ), Hopi.

Pahaanna, "Anglo; anyone of European extraction," Hopi.

Papaguería, 'Land of the Papagos,' Spanish.

Pisísvaiyu, "Where Water Flows" (Colorado River, Grand Canyon, AZ), Hopi.

Sà'hndè dò t'àn (San Carlos Apache), Apache.

sapim, "giant basket," Seri.

S-cuk Do'ag, "Black Mountain" (Sierra Pinacate, Sonora, Mexico), Pápago.

Semana Santa, "Holy Week" (Easter week), Spanish.

Síhuki, "Elder Brother's House" (sacred cave), Pápago.

Sipápuni, "Place of Emergence" (Little Colorado River Gorge, AZ), Hopi.

Sisnaajiní, "Horizontal Black Belt" (Blanca Peak, Sangre de Cristo Mountains, CO), Navajo.

Tahéöjc, "Tiburon Island," Seri.

Tahéöjc Imozit, "The Heart of Tiburon," Seri.

tinajas, "stone rain catchments," Spanish.

Tí-yo, "The Youth" (snake hero), Hopi.

Tjukson, "Foot of the Black Hill" (Tucson, AZ), Pápago.

Tjunikáak, "Where There Is Sahuaro Fruit" (Bates Well, AZ), Pápago.

Tł'aa'í, "Left Handed" (surname for headman named Cly), Navajo.

Tohono Ó'odham, "Desert People," Pápago.

tóka, "double-ball," Pápago.

Tsé bii' Ndzisgaii, "Clearings Among the Rocks" (Monument Valley, AZ/UT), Navajo.

Tséé Zhinnéé, "People of the Dark Rocks" (Aravaipa Apache), Apache.

Tséyi', "In Between the Rocks" (Canyon de Chelly, AZ), Navajo.

Tsíí' łigaii, "White Hair" (Ute warrior), Navajo.

Tsé Ts'óózi, "Slim Rock" (Totem Pole, Monument Valley, AZ), Navajo.

Tusqua, "the land," Hopi.

Tutuventiwngwu, "Place of the Clan Rocks" (Willow Springs, AZ), Hopi.

vak, "bullrush" (Quitovac, Sonora, Mexico), Pápago.

Vavkívolik, "Mountain Narrow in the Middle" (Baboquivari Mountains, AZ), Pápago.

Yéi Becheii, "Grandfather of the Yé'ii [deities]" (Yéi Becheii spires, Monument Valley, AZ), Navajo.